To
Dick Stewart –
Thanks for your
teaching and friendship

Steve Armes
7/90

THE ANNE BURNETT TANDY LECTURES
IN AMERICAN CIVILIZATION

NUMBER FIVE

The American Pupils of Jean-Léon Gérôme

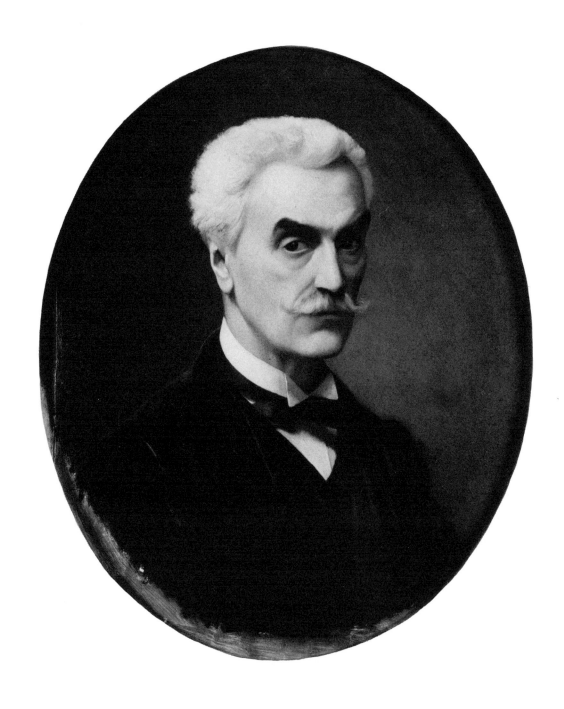

1. Jean-Léon Gérôme, *Self Portrait*, 1886. Oil on canvas. Signed.
Collection of the Aberdeen Art Gallery and Museum, Aberdeen, Scotland.

The American Pupils
of Jean-Léon Gérôme

H. BARBARA WEINBERG

Amon Carter Museum
Fort Worth, Texas: 1984

AMON CARTER MUSEUM OF WESTERN ART

The Amon Carter Museum was established in 1961 under the will of the late Amon G. Carter for the study and documentation of westering North America. The program of the museum, expressed in permanent collections, exhibitions, publications, and special events, reflects many aspects of American culture, both historic and contemporary.

These lectures were presented April 30, 1983

Table of Contents

To the Reader

DURING THE LAST TWENTY YEARS, nineteenth-century American art has attracted unprecedented interest. This is the result of several factors. The emergence of New York as the center of the international art world, and widespread attention to abstract expessionism and succeeding American styles, appear to have engendered curiosity about earlier American art. The extraordinary economic health of American painting in the art market has brought to light the works of dozens of heretofore unknown nineteenth-century artists, and provoked interest in their careers.

Academic recognition of historical American art has paralleled and reinforced critical and commercial recognition. Numerous scholarly exhibitions and new museum installations of nineteenth-century American art have focused attention upon individual artists and stylistic and thematic trends. A learned publication, *The American Art Journal*, which is specifically devoted to historical American art, has been flourishing since 1969, and others solicit contributions in this field. The Archives of American Art, a unique research resource, has expanded its holdings and facilities and enjoys greatly increased use. There has also been a gratifying growth in the teaching of American art in our universities. Undergraduates have discovered its appeal and its relevance and have prompted European-oriented art history faculties to add American art courses to their curricula. Doctoral programs have also increased their offerings and, in two instances—the University of Delaware and the City University of New York—have made American art a decided specialty.

As younger scholars have begun to examine this exciting field, they have increasingly scrutinized late nineteenth-century art, an area little explored by Americanists prior to 1970. Their few predecessors had searched for "what is American in American art," and thus concentrated on more "native," antebellum styles. By contrast, many of these younger scholars have been investigating the extremely international manner that characterized late nineteenth-century American painting, sculpture, and architecture. Stimulated in part by the return to figuration and to acutely detailed realism by certain contemporary American painters and sculptors, and by the development of post-modern architectural styles, younger art historians are exploring the academic art of the late nineteenth century. The concurrent re-evaluation of European academic teachers and institutions by such American scholars as Gerald M. Ackerman, Albert

Boime, Arthur Drexler, and Gabriel P. Weisberg, has supported these investigations. Thus, many American artists, such as Thomas Hovenden and Charles Follen McKim, heretofore ignored because of their debt to European academic training, have been the subject of recent monographic studies. Others, such as Thomas Eakins and Louis Sullivan, who had been viewed by earlier, culturally nationalist writers as untouched by cosmopolitan tendencies, have been reexamined in relation to their European sources and connections.

In inviting me to present the Anne Burnett Tandy lectures on *The American Pupils of Jean-Léon Gérôme* in April 1983, the Amon Carter Museum declared its concern with these newer trends in American art history. It had already disclosed such concern by displaying the exhibition, *Americans in Brittany and Normandy, 1860–1910*, organized by the Phoenix Art Museum, the preceding winter, and by hosting a stimulating symposium related to that exhibition. For the Museum's interest in cosmopolitan tendencies in late nineteenth-century American art, and for its hospitality on the occasions of both the symposium and the Tandy lectures, I am most grateful.

I am also grateful for this opportunity to publish my observations on the American pupils of Gérôme under the terms of the Tandy bequest. What follows is an edited version of the lectures. Owing to requirements of space, I have had to omit illustrations of many of the works that I had shown and discussed. At the same time, I have added much detailed information on individual artists and their paintings, as well as citations to published and manuscript sources. Such information is always better read than heard.

Like the lectures, this publication necessarily concentrates on but a few of Gérôme's scores of American pupils, artists who shared certain provocative intellectual and artistic commitments. This group either established major reputations in their own time, or, as is the case with Eakins, attracted substantial scholarly attention in the twentieth century. As these artists' works have been preserved in significant numbers, and as their observations on their training have been recorded in most instances, they were among the most fruitful of Gérôme's pupils to investigate and the most likely to offer methodological models for other studies. For ease of reference in this context, I have appended a roster of all of the American pupils of Gérôme, which includes a few émigrés from Europe and Canadians who also studied or worked in the United States. This roster was transcribed from the atelier register of the Ecole des Beaux-Arts, now preserved in the Archives Nationales, Paris.

In general, then, this book constitutes more than I could say in the three hours of the Tandy lectures themselves. However, it also constitutes much less than I have to say on the subject of Gérôme and his American pupils. In fact, this book sets forth only a small part of a larger study of the impact of French training upon nineteenth-century American painters, upon which I have been engaged

for some time and which is nearing completion. Like the present publication, that study should both reflect and assist the growth of scholarly interest in late nineteenth-century artistic cosmopolitanism and its relation to the cultural conditions and aspirations of that fascinating period in American history.

It is a pleasure to acknowledge the interest of Ruth Carter Stevenson, Chairman of the Board of Trustees of the Amon Carter Museum, in my research, and the consideration of the outstanding staff of the Museum—especially William Howze, Ron Tyler, Margaret Blagg, and Mary Lampe—in arranging details of the lectures and of this publication. I am much indebted to the museums, art dealers, and collectors who provided photographs of works pertinent to the present study and granted me permission to reproduce them. The helpful and courteous staff of the Archives Nationales, Paris, offered crucial assistance during my research. I owe many thanks to Professor Gerald M. Ackerman, Dr. Doreen Bolger Burke, and Professor William H. Gerdts, both for sharing my interest in the cosmopolitan aspects of late nineteenth-century American painting and for sharing insights and information. My students at the Graduate Center of the City University of New York, who have enthusiastically joined me in investigating individual artists and issues, have my deep appreciation as well. John Lowenthal, Esquire, and Dr. Anne W. Lowenthal provided patient and invaluable technical assistance, for which I am very grateful. Finally, and as always, I thank my friend and husband, Michael B. Weinberg, for his unfailing support of my work.

H.B.W.
New York City
February 1984

INTRODUCTION

The Lure of Paris

IN THE DECADES AFTER THE CIVIL WAR, the United States enjoyed unprecedented participation in international political, economic, scientific, and social affairs. This world-wide engagement on all practical fronts was matched by a spirit of internationalism in cultural matters. Assisted by newly accessible transportation and improved communication, American artists optimistically and energetically sought full involvement in the European art world. Paris assumed undisputed world leadership in taste and artistic training, and became an irresistible magnet for hundreds of American art students, including almost two thousand painters born by 1880. The city was a storehouse of older art treasures, like London and Rome, but it also exuded a unique and pervasive artistic atmosphere and took an unusual interest in contemporary creative developments. An American painter, writing in a popular journal in 1881, reported from Paris: ". . . a vast art-world surrounds the student, into the midst of which he is plunged, wondering, enjoying, benefitting by it all, but often in ways he had least expected. In Italy he will live among the treasures of bygone ages; here, though surrounded by representative work of all time, he is at the centre of the most active, earnest effort of the present."[1]

The characteristic picturesqueness of the city also exercised its appeal. Describing the expatriate painter, Henry Bacon (1839–1912), who anchored his professional life in Paris after 1864, one writer noted: "He would rather live in this city on a crust than in any other on six courses and dessert. The streets often as he has seen them form an ever new picture for him. A French crowd seems to be spontaneously composing all the time without giving the artist the trouble to set the model."[2]

"Living on a crust" in Paris appears to have been feasible, as cheap accommodations were available. For example, Abbott Handerson Thayer and his new wife arrived in Paris in July 1875 and rented a room in the Hôtel Britannique, opposite the Théatre Châtelet, which was to be their home for the next three years. The room was up five flights of stairs, and there was no elevator, but Thayer described it as "good sized" and "pleasant" in one of his first letters home, and recorded costs and budget:

1. Phebe D. Natt, "Paris Art-Schools," *Lippincott's Magazine* 27 (March 1881): 269.
2. Richard Whiteing, "Henry Bacon," *Art Amateur* 7 (November 1882): 115.

Our food and the fuel that cooks it cost us, so far, under four dollars a week and we know now how to have the same for $3.50, and our present room costs us, with service, (the room furnished, beds, etc., taken care of in the service) $96.00 a year, but we intend to be in a somewhat more elegant and spacious one before this reaches you, which will cost us $144.00 a year. I married on $1970.00 U.S. money and one hundred due. . . . You see if this were expected to last three years, the board and lodging taken from one-third of it, calling the board and lodging $350.00 U.S. money, leaves three hundred a year for all extras, out of which, at present rate (being time of outfit, crockery, etc.) we really are likely to save something, or be able to pay for long sickness. . . . I have not made much less than five hundred dollars by my work any year since I was eighteen years old, eight years ago, and of course you know that my work will be more valued at home now I am here. . . .[3]

While the Thayers' fourth and last year in Paris—one that had been urged on him by his teacher, Jean-Léon Gérôme—necessitated their living even more frugally on borrowed money—"He went from market to market to get fish that cost one sou less," a friend recalled[4]—their budget does not appear to have been uniquely modest.

Joe Evans (1857–1898), a landscape painter, a friend of Thayer's, and a compatriot in Gérôme's studio from 1877 to 1880, also recalled very low expenses in response to an inquiry from Dennis Miller Bunker in August 1882. Bunker, who was then planning his own Parisian sojourn, acknowledged the practical information that Evans had provided. He added, "I was rather surprised to find that you had lived in Paris on an average of a dollar a day, most agreably [sic] surprised. I assure you, not that I think I could live on that am't myself, but still I think that I could come pretty near it, say a dollar and a half, exclusive of clothes, and as I'm not much of a swell in this respect I don't think I would spend much over them."[5]

Aside from the pleasures and practicability of study in Paris, American artists were drawn there by the desire to learn to emulate the academic, Barbizon, and, ultimately, Impressionist painters whose works were increasingly attractive to American collectors. American acquisitions of French paintings were so extensive by 1886 that the French government sent an investigator to report on private collections in the United States. His published account verified official worries about the huge exportation of contemporary French art to America: "I

3. Thayer to Ernst Perabo, 22 July 1875, quoted in Nelson C. White, *Abbott H. Thayer: Painter and Naturalist* (Hartford, Connecticut, 1951), pp. 22–23.
4. Anonymous letter dated 1918, Archives of American Art, Thayer Papers; see also White, *Thayer*, p. 29.
5. Bunker to Joe Evans, 9 August 1882, Archives of American Art, Bunker Correspondence.

would never have believed, had I not confirmed it myself, that the United States, so young a country, could be so rich in works of painting, especially works of the French school. It is not by the hundreds but by the thousands that one must count them."[6]

American painters' perceptions of the need for French training in the period after the Civil War are summed up in the recollections of Edwin Howland Blashfield. Blashfield told his biographer that, at the age of seventeen, he had sought the advice of William Morris Hunt (1824–1879) with respect to art study. Hunt, a pioneer among American painters in seeking French training, had studied in the Parisian atelier of Thomas Couture (1815–1879) between 1846 and 1852, and had then worked with Jean-François Millet (1814–1875) at Barbizon for three years. Recalling his visit to the older artist in Boston in April 1866, Blashfield noted: "Hunt . . . said to me 'Go straight to Paris. All you learn here you'll have to unlearn.'"[7] Ultimately, American art students became so habituated to going to Paris that they did so almost automatically. Asked why he had gone there in 1889, William MacGregor Paxton told an interviewer many years later: "Just wanted to. I always had idea don't know how. Read about all fellows coming back."[8]

Beginning with Hunt's generation, study in Paris radically altered late nineteenth-century American painting, with more and more students enrolling in a variety of studios and art schools in each succeeding decade. If, as appears to have occurred, students who went to Paris in the 1890s stayed for shorter periods of time than did those who had gone in the 1860s and 1870s, it was probably because they had already experienced training in the French manner at home, under such teachers as Hunt and Bunker. Their earlier return was also encouraged by the development of a newly rich and serious American art-life—including unprecedented commissions for mural painting, expanded exhibition and studio facilities, and more sophisticated critical interest—all of which had been stimulated by French models.

6. E. Durand-Gréville, "La Peinture aux Etats-Unis," *Gazette des Beaux-Arts* 36 (July 1887):65; quoted in Alexandra R. Murphy, "French Paintings in Boston: 1800–1900," in *Corot to Braque: French Paintings from the Museum of Fine Arts, Boston* (exh. cat., Museum of Fine Arts, Boston, 1979), p. xvii.

7. Blashfield quoted in Royal Cortissoz, *The Works of Edwin Howland Blashfield* (New York, 1937), unpaginated.

8. Paxton quoted in interview with DeWitt McClellan Lockman, 4 May 1927, New-York Historical Society, Lockman Papers (Archives of American Art microfilm).

The Ecole des Beaux-Arts and Jean-Léon Gérôme

THE PRINCIPAL AND MOST DISTINGUISHED French institution for artistic study was the government school, the Ecole des Beaux-Arts, which accepted students (men only, until 1897) tuition-free, without regard to nationality. In 1863, a crucial curriculum reform at the Ecole made it the Western world's preeminent art school, and the model for international emulation. Until that date, the only practical instruction offered to matriculants was in cast and life drawing, supervised by a rotating faculty of twelve critics. A matriculant learned all other techniques in the independent atelier of a master who might or might not have been a member of the Ecole's faculty. As a result of the reform of 1863, the curriculum of the Ecole became more comprehensive and its entire aspect more fully professional. Lecture courses provided instruction in anatomy and perspective for painters and sculptors, as they had even in the earlier period. But the lecture curriculum was expanded and enriched by the addition of weekly and bi-weekly instruction in history and archaeology, aesthetics and art history, and later, literature, ornamental design, and decorative art. Supplementary lecture series were also instituted. Drawing, a matriculant's central commitment, was now taught by a single teacher, Adolphe Yvon (1817–1893), who remained in charge of this aspect of instruction until the Ecole's curriculum was again expanded in 1883.

As in the period before 1863, a matriculant in the Ecole's drawing course would obtain most of his practical instruction in the atelier of an individual master, but a crucial alteration in the structure of the Ecole occurred in that year. The joined section of painting and sculpture was divided in two, and three ateliers for instruction in each medium were established within the physical and administrative domain of the Ecole. Like the ateliers in other media, including the three established in the architecture section, the three ateliers for painting assumed independent lives until after the Second World War, at least. That is, each of the three *chefs d'atelier* was individually succeeded upon his resignation or death. Thus, the three initial ateliers—those of Jean-Léon Gérôme (1824–1904), Alexandre Cabanel (1823–1889), and Isidore Pils (1815–1875)—remained essentially discrete for at least eighty years, each generating its own series of "begats" in its *chefs*.[9]

9. For the curriculum reform of 1863, see Albert Boime, "The Teaching Reforms of 1863 and

A student gained admission to one of the Ecole's three painting studios by personal application to the *chef d'atelier*. The *chef* would often require the student to undergo a period of supervised work as an *aspirant*, drawing from casts in the gallery of antiques, before he would certify him for admission to the studio itself. Inscription in one of these studios did not obligate a student to compete in the rigorous *concours des places* for matriculation in the Ecole proper, that is, in Yvon's or his successors' drawing course. This competition included tests in anatomy, perspective, cast or life drawing, and, after 1883, in the principles of sculpture and architecture. Admission was limited to only seventy students until 1883, and eighty thereafter. Some Americans, such as Thayer and Julian Alden Weir, were pupils in an Ecole atelier as well as matriculants. Others appear to have avoided the competition for matriculation; still others failed it. Matriculation, as in Thayer's case, was often for only a single semester in the course of years of atelier study, and the number of pupils inscribed in the three ateliers for painting far exceeds the number of those matriculated. Yet another option, recalling arrangements that had prevailed prior to 1863, was exercised by some Americans, including John Singer Sargent (1856–1925) and Robert Henri (1865–1929). These painters studied with independent teachers or at other art schools, and yet matriculated for drawing instruction in the Ecole.[10]

A typical student in one of the Ecole's ateliers could expect to work from October to July, six mornings per week, first at drawing and then at painting from life, with one week each month devoted to study from the antique. His afternoons might be spent in sketching paintings or sculpture in the Louvre or Luxembourg galleries. Matriculants would devote their evenings to working in the Ecole's drawing course. To assist success in producing works based on historical, mythological, or religious texts, the ambitious student would squeeze attendance at lectures and library research into the day. This hectic routine was punctuated by numerous studio competitions, and others in compositional sketching, historical landscape, or "expressive heads," which were open to all students in the Ecole. (Only the competition for the *Grand Prix de Rome* was

the Origins of Modernism in France," *Art Quarterly*, n.s. 1 (1977): 1–39. For the Ecole's faculty between 1863 and the beginning of the twentieth century, and the curriculum reform of 1883, see my "Nineteenth-Century American Painters at the Ecole des Beaux-Arts," *American Art Journal* 13 (Autumn 1981): 66–84.

10. Sargent, a student in the independent atelier of Carolus-Duran, matriculated in three semesters: fall 1874, spring 1875, and spring 1877. Henri, a student of William Adolphe Bouguereau and Tony Robert-Fleury at the Académie Julian, failed the *concours* of February and June 1889 and February and June 1890; he finally matriculated in February 1891 for one semester. Archives Nationales, Paris, Archives de l'Ecole Nationale Supérieure des Beaux-Arts, *Procés-verbaux originaux des jugements des concours des sections de peinture et de sculpture. 1874–1883* (AJ52:78); *1889–1894* (AJ52:80).

restricted—to French citizens.) Additionally, the student had to undergo the semi-annual *concours des places* if he wished to matriculate, or to maintain matriculation in the absence of a sufficient number of prizes.

Quite as nerve wracking were the semi-weekly studio visits of the *chef d'atelier*. Recalling those visits by his teacher, Gérôme (fig. 1), the American portraitist and illustrator, Stephen Wilson Van Schaick (1848–1920) wrote:

> Quick of vision and unmerciful in judgment, he dominated, by a singular magnetism, the student who gladly submitted to his terrible "ce n'est pas ça" and who scarcely felt elated with the seldom heard "pas mal"—such confidence he inspired in his sincerity in holding before us the same high standard of excellence toward which he also struggled. This *personality* was so strong in Gérôme that his presence was sufficient to drive myself and others into hiding and relieve him of the trouble of judging us. It elevated us, in the moment, beyond our capacity; our errors glared in our work, we saw with his eyes, said to ourselves the unsympathetic "more simple," "it is not that," *judged* ourselves, only to return to our weakness on his departure.[11]

Some idea of Gérôme's actual teaching methods may be gleaned from the recollections of another, unnamed American artist, "a New Yorker, formerly a pupil of his at the Beaux Arts." This student, who was quoted in a commemorative article, recorded Gérôme's habit of giving short, informal technical or inspirational lectures in the class and his comparative judgings of his students' works.

> His words were few, and he never really lectured to his classes. When, however, a pupil seemed to him especially promising he would often stop before the young man's work and discuss it with grave care.
>
> Sometimes such criticism led the master into a little disquisition on principles or methods, and then as he talked first one and then another of the pupils would leave his own work and draw near to hear what was going on. Thus perhaps a considerable body of the pupils would gather, and the talk of the master became something like a little lecture. . . .
>
> If nothing in the way of verbal criticism reached a pupil there was a chance that the master's opinion would penetrate when once in three months he took the work of all, lined the canvases against the wall and numbered them in order of merit. This he did with enormous patience and

11. Van Schaick in "Open Letters: American Artists on Gérôme," *The Century* 37 (February 1889): 636.

pitiless severity. It was a proud man who then had first choice of the place before the model as a result of this adjudication.[12]

Of the three ateliers for painting established at the Ecole des Beaux-Arts in 1863, Gérôme's was by far the most popular among American students, despite or because of his rigorous standards, and despite the fact that he professed no knowledge of English.[13] A leading exponent of Beaux-Arts principles, Gérôme was considered an especially attractive and generous person and teacher. The characterization offered by a French critic twenty years after his appointment as *chef d'atelier* typifies contemporary international opinion:

> Gérôme remains at sixty years of age the same as he was at thirty-six: as youthful, vigorous, active and wiry, as full of life and sympathetic. An agreeable, gay talker, pensive notwithstanding his good humor, respectful of his art, frank and loyal, adored by his pupils, he is the professor who teaches the young those rare and neglected virtues: simplicity, study and labor. In a word he is a noble example of what a master-painter of the nineteenth century may be: an artistic soul with a soldier's temperament, a heart of gold in an iron body.[14]

Gérôme's involvement with his pupils extended beyond the atelier. He was willing to have them bring their paintings to his own studio for review, to counsel them on strategies for Salon acceptance, and occasionally to intervene on their behalf on Salon juries. He also advised them about independent study in the museums of Paris, about summer sketching trips, and about visits to museums throughout Europe. He maintained a close interest in the activities of former pupils and generously offered help to pupils enrolled in other ateliers, including such American painters as Blashfield, Edwin Lord Weeks, and Mary Cassatt (1844–1926).[15] Gérôme's personal durability in contrast to that of any of his colleagues among the *chefs d'atelier* provided a unique continuity for his American pupils. Those who had experienced his instruction in the 1860s and 1870s encouraged younger American artists, including their own pupils, to follow the same course later in his forty-year tenure at the Ecole.

In January of 1863, the year of his appointment as *chef d'atelier*, Gérôme had made a fortunate marriage to Marie Goupil, the daughter of the influential art

12. "Gérôme Among His Pupils," clipping from an unidentified newspaper, dated 24 January 1904, bound into New York Public Library copy of Fanny Field Hering, *Gérôme, his life and works* (New York, 1892).

13. Hering, *Gérôme*, p. v.

14. Jules Claretie in *The Great Modern Painters*, quoted in Nancy Douglas Bowditch, *George deForest Brush: Recollections of a Joyous Painter* (Peterborough, NH, 1970), p. 9.

15. Gérôme's relationship with Blashfield and Weeks will be discussed below. His counsel to Cassatt in 1866 is documented in Nancy Mowll Mathews, "Mary Cassatt and the 'Modern Madonna' of the Nineteenth Century," unpublished Ph.D. dissertation, Institute of Fine Arts, New York University, 1980, pp. 16–20.

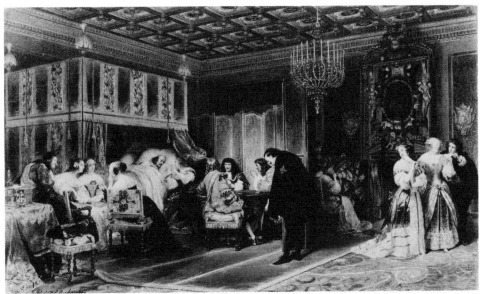

2. Hippolyte (Paul) Delaroche, *Cardinal Mazzarin's Last Sickness*, 1830. Oil on canvas.
22½ x 38½ inches. Signed and dated.
Reproduced by permission of the Trustees of the Wallace Collection, London.

dealer and publisher.[16] As a result, the artist had easy and continued access to a distributor of photogravures after his paintings. The availability of photogravures of Gérôme's compositions also assisted their emulation long after the original paintings were completed and entered private collections. Many of his most popular works of the 1850s and '60s, when his inventions were most varied and his execution strongest, are recalled in his pupils' works decades later. Photogravures also enhanced Gérôme's world-wide reputation, particularly in the United States, and kept collectors and former pupils aware of his latest achievements. American interest was also attested and served by the publication of two sumptuously illustrated monographs on Gérôme in New York, Earl Shinn's in 1881–1883, and Fanny Field Hering's in 1892.[17]

Gérôme was born in 1824 in Vesoul, near Basel, in eastern France, the son of a goldsmith, who encouraged his interest in art. At the age of sixteen, after extensive study of drawing and painting at the *lycée* in Vesoul, he entered the Parisian studio of Paul Delaroche (1797–1856). Here Gérôme remained until De-

16. The most accessible source of biographical information on Gérôme is *Jean-Léon Gérôme (1824–1904)*, essays by Gerald M. Ackerman and Richard Ettinghausen (exh. cat., Dayton Art Institute, 1972). Professor Ackerman's descriptions of the themes of many of Gérôme's history paintings have also been of great assistance to this study. Ackerman's more extensive monograph on Gérôme and *catalogue raisonné* are in press (Paris, Arthena). I am grateful for his generosity in sharing new information with me in advance of this publication. See also Pierre Chantelat, Albert Benamon, Jacques Foucart et al., *J. L. Gérôme 1824–1904* (Vesoul, 1981).

17. Earl Shinn [Edward Strahan], ed., *Gérôme, a collection of the works of J. L. Gérôme in one hundred photogravures* (New York, 1881–83); Hering, *Gérôme* (see note 12). The latter is based extensively upon Gérôme's autobiographical notes of 1876, for a complete transcript of which, edited by Gerald M. Ackerman, see *Bulletin de la Société d'agriculture, lettres, sciences et arts de la Haute-Saône*, n.s. 14 (1980): 1–23.

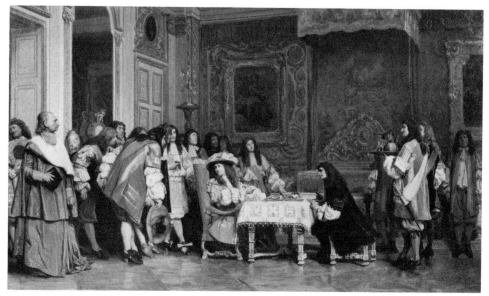

3. Jean-Léon Gérôme, *Molière Breakfasting with Louis XIV*, 1862. Oil on panel. Signed.
16½ x 29½ inches. Reproduced courtesy of the Malden Public Library, Malden, Massachusetts.

laroche left most of his students to Charles Gleyre (1808–1874) in 1843, and
became his master's favorite pupil and, later, his assistant and friend. Delaroche's
lapidary technique and typical subject interests are evident in such works as *Car-
dinal Mazzarin's Last Sickness* (1830; fig. 2), which records the poignant death
in 1661 of the once-feared cardinal in a room full of now indifferent courtiers to
Louis XIV. Such paintings appear to have conditioned Gérôme's later concern
with meticulously detailed tableaux drawn from modern history. As his teacher
had done in *Cardinal Mazzarin*, Gérôme presented a bit of seventeenth-century
"genrefied" history—that is, history conjoined with routine activities and "the
facts of life" (or death)—in such a work as *Molière Breakfasting with Louis XIV*
(1862; fig. 3), arranging it as if it were a scene from one of Molière's own plays.
Here, Louis XIV honors his court dramatist at his own table in the royal bed-
room at Versailles, while admonishing the snobbery of the discomfited courtiers
who held Molière in disdain. (Mazzarin appears again here as well—the first
fully depicted, indignant figure at the left.)

Generally, Delaroche imparted to his student a commitment to lucid, stage-
like compositional construction and diligent research of settings, props, and cos-
tumes, whatever the subject. Derived from Delaroche's procedures are those that
Gérôme followed for *The Dance of Almeh* (1863; fig. 4) and *Ave Caesar, Morituri
Te Salutant* (1859; fig. 5). He engaged in extensive sketching, referred to pho-
tographs, and purchased Near Eastern costumes and rugs for the former paint-

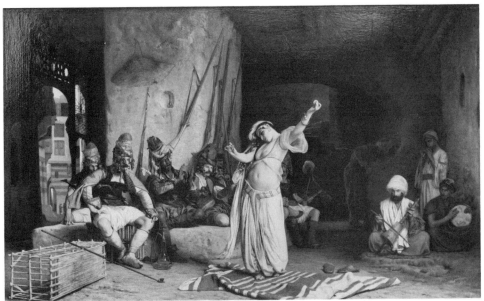

4. Jean-Léon Gérôme, *The Dance of Almeh*, 1863. Oil on panel. 19¾ x 32 inches. Signed and dated. The Dayton Art Institute, Gift of Mr. Robert Badenhop, 51.15.

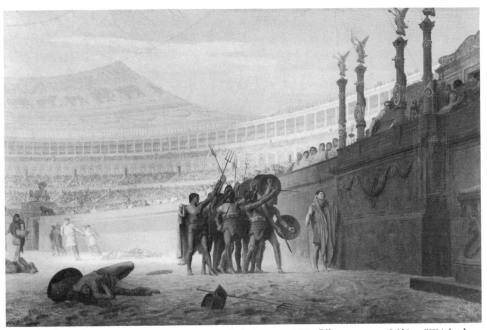

5. Jean-Léon Gérôme, *Ave Caesar, Morituri Te Salutant*, 1859. Oil on canvas. 36⅝ x 57¼ inches. Signed and dated. Yale University Art Gallery, Gift of C. Ruxton Love, Jr., B.A., 1925.

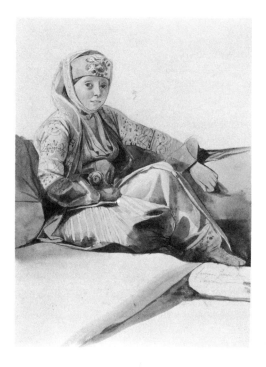

6. Charles Gleyre, *Femme Juive de Smyrne*, 1834. Watercolor on paper. 12⅝ x 9¼ inches. Loan from Lowell Institute. Courtesy, Museum of Fine Arts, Boston.

ing, which presents a belly dancer, accompanied by musicians and observed by Bashi Bazouks—Turkish mercenaries—in a dingy Egyptian café. For *Ave Caesar—Hail! Caesar, we who are about to die salute you!*—he studied Roman bronzes, modelled small wax maquettes, and consulted with an archaeologist to accurately "reconstruct" the Colosseum and to ensure our empathy with the gladiators whom we join on the sandy, bloody arena floor.

Rather than to Delaroche, the subjects of *Almeh* and *Ave Caesar*—Near Eastern genre and classical genre—are related to Gérôme's contact with Gleyre, in whose Paris studio he worked for some three months during 1845, after a year's sojourn in Rome with Delaroche. While he later declined to admit any influence from Gleyre, Gérôme was probably stimulated by his second teacher's travel in the Near East in the early 1830s, which produced numerous images of exotic genre, such as his *Femme Juive de Smyrne* (1834; fig. 6). Gleyre's commitment to a humanized interpretation of classical subjects also affected Gérôme's works. This tendency, actually reinforced by the interests of his students, culminates in such a late work by Gleyre as the anti-dramatic, "genrefied" *Sappho Going to Bed* (1867; fig. 7). The specific historical references here are so minimal that the painting may be read simply as an image of an anonymous nude female pouring oil into a lamp.

Like Gleyre, Gérôme often illustrated ancient narratives that could be explored for their psychological or erotic, rather than their didactic or moralistic

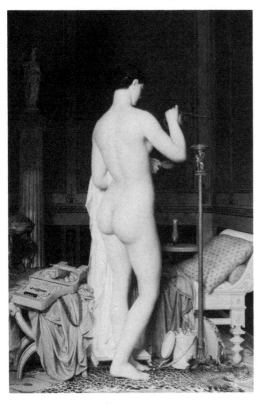

7. Charles Gleyre, *Sappho Going to Bed*,
1867. Oil on canvas. 48½ x 28½ inches.
Signed. Musée Cantonal des Beaux-Arts,
Lausanne.

quotients. For example, *King Candaules* (1859; fig. 8), based on a text of Hero-
dotus which had inspired a story of 1844 by Théophile Gautier, involves voy-
eurism rather than heroism. The Lydian King had ordered Gyges, his captain of
the guard, to observe his wife's extraordinary beauty as she disrobed one night.
When Queen Rodope realized that her modesty had been compromised, she of-
fered Gyges a choice between killing himself and killing her husband. Not sur-
prisingly, he agreed to the latter. We see him entering the bed chamber to com-
mit assassination at Rodope's signal as apprehension overtakes the King, whom
Gyges will replace as both ruler and husband.[18]

Gérôme easily moved from this sort of intimate, witty, "genrefied" classical
history painting to straightforward classical genre, images of everyday life unen-
cumbered by any specific narrative, such as *The Roman Slave Market* (1857;

18. The painting has been described as depicting the moment of Gyges's first intrusion and
the Queen's realization of the voyeur's presence in Julius S. Held, *Museo de Ponce. Catalogue:
Paintings of the European School.* (Ponce, Puerto Rico, 1965), p. 73, and Ackerman, *Gérôme*, (exh.
cat., Dayton, 1972), p. 42. Professor Ackerman's monograph, in press, significantly and per-
suasively corrects that description in accordance with notes by Gautier, who recorded the moment
chosen after a visit to the artist's studio in 1858. I am most grateful to Professor Ackerman for
permitting me to correct my own misapprehension of the painting here.

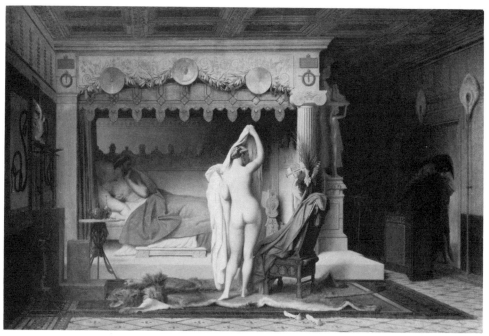

8. Jean-Léon Gérôme, *King Candaules*, 1859. Oil on canvas. Signed and dated. 26 x 38⅜ inches. Museo de Arte de Ponce (Fundación Luis A. Ferré).

Butler Collection, Phoenix) and *A Roman Slave Market* (c. 1884; fig. 9). From classical genre, he made another easy and durable transition to exotic contemporary genre as in *The Pifferari* (1859; fig. 10), an image of mendicant Italian shepherds who come to Rome (even today) to play their bagpipes at Christmas. Most often, however, Gérôme's exotic genre subjects are Near Eastern, as in *The Slave Market* (1867; fig. ll). Following in Gleyre's footsteps in the Near East, and sensitive to his era's interest in fact, he established a reputation as one of the most prolific and popular late nineteenth-century orientalists. While he continued to paint and exhibit "genrefied" history and classical genre, and even autobiographical genre, such as *The End of the Seance* (1887; fig. 12), he devoted his greatest attention to, and earned his greatest acclaim and patronage as, an ethnographic realist.

The debut of Gérôme's interest in classical genre was *The Cock Fight* of 1846 (fig. 13), shown in the Salon of the following year, where it received a third class medal. Having been unsuccessful in the Prix de Rome competition in 1846, Gérôme realized, he recalled, "Decidedly I needed to draw and model the nude. It was with this intention of *study* that I painted my first picture, *Jeunes Grecs Faisant Bâttre des Coqs*."[19] The theme, thus, is little more than an excuse to ex-

19. Gérôme quoted in Hering, *Gérôme*, p. 51.

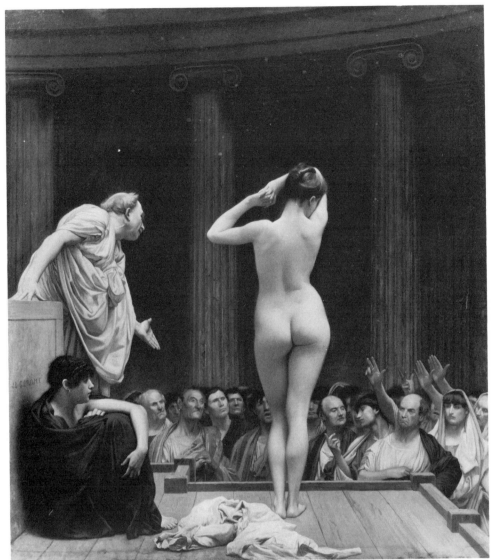

9. Jean-Léon Gérôme, *A Roman Slave Market*, c. 1884. Oil on canvas. Signed. 25¼ x 22½ inches. The Walters Art Gallery, Baltimore.

plore contrasting masculine and feminine anatomies, attitudes, and gestures at life size. An unusual academic work for its time, *The Cock Fight* depends on no specific historical associations and conveys hardly any narrative content at all. However, its scale is that of a traditional history painting. Thus, the "death of narrative," which has been claimed as an innovation of such Realists as Gustave Courbet—who appropriated the scale of history painting to depict inconsequential themes in the later 1840s—is prefigured by Gérôme's work of 1846.

The interest in animal anatomy that appears in *The Cock Fight* reflects Gérôme's friendship with the animal sculptor, Emmanuel Frémiet (1824–

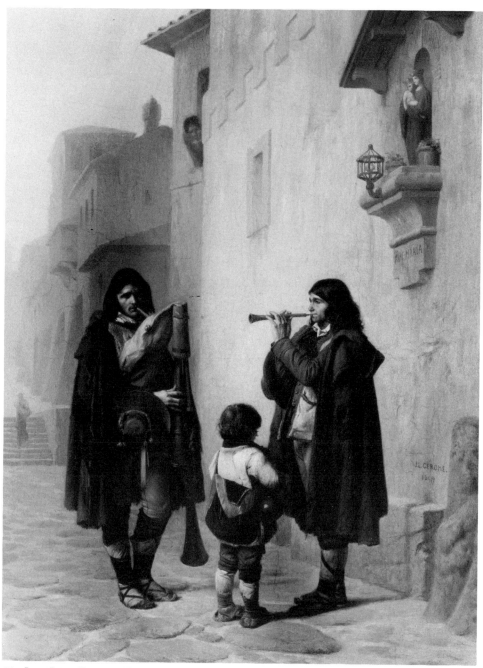

10. Jean-Léon Gérôme, *The Pifferari*, 1859. Oil on panel. Signed and dated. 15¾ x 12¾ inches.
H. Shickman Gallery, New York.

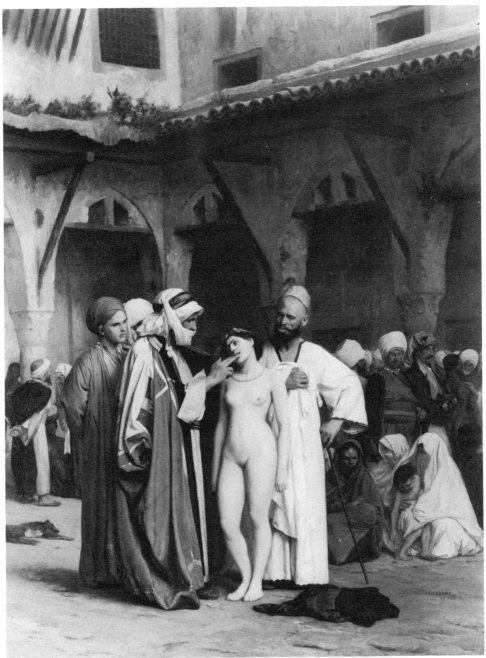

11. Jean-Léon Gérôme, *The Slave Market*, 1867. Oil on canvas. Signed. 33³/₁₆ x 24¹³/₁₆ inches. Sterling and Francine Clark Art Institute, Williamstown, Massachusetts.

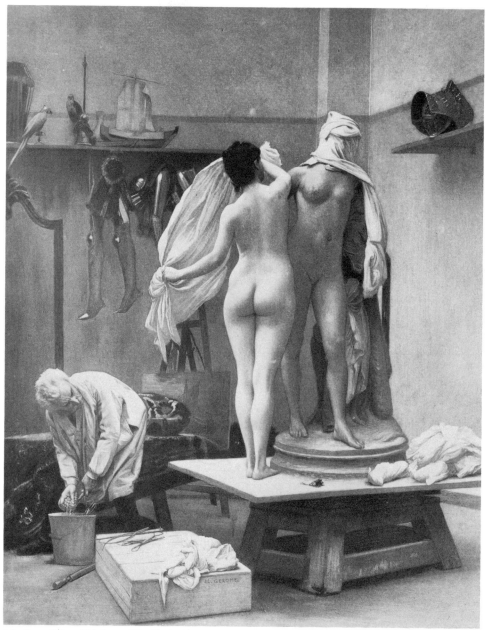

12. Jean-Léon Gérôme, *The End of the Seance*, 1887. Signed. Whereabouts unknown. Photo:
Fanny Field Hering, *Gerome, his life and works* (New York, 1892), courtesy Gerald M. Ackerman.

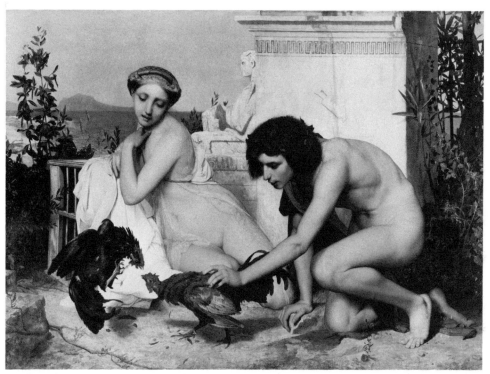

13. Jean-Léon Gérôme, *The Cock Fight*, 1846. Oil on canvas. Signed and dated. 56¼ x 81½ inches. Musée du Louvre, Paris.

1910). Animal imagery would inform many of Gérôme's later works as well, often figuring as the subject for major paintings. His contact with Frémiet also seems to have stimulated Gérôme's own concern for sculpture as a study aid in the rendering of volumetric forms in paintings and as an independent medium. Under Frémiet's guidance in 1873, Gérôme would make his first experiments as a sculptor of works related to, and yet independent of his paintings.

Despite the tremendous attention directed to Thomas Couture's *Romans of the Decadence* (Musée du Louvre, Paris) in the Salon of 1847, the twenty-two year old Gérôme attracted ecstatic praise for *The Cock Fight*, and continued to receive support from influential critics. Gautier, for example, saw in the "neo-Grec" grace of Gérôme's art a welcome antidote to the vulgarity of burgeoning Realism. Concurrent with critical approbation were many and varied private commissions that Gérôme received throughout the 1850s. These include portraits of fashionable women, such as that of *Mlle. Durand* (1853; fig. 14), an actress at the theater of the Palais Royale. This image shares mood and manner with contemporary portraits by J. A. D. Ingres (1780–1867), such as his *Mme. Inès Moitessier* (1851; National Gallery of Art, Washington, D.C., Samuel H. Kress Collection).

14. Jean-Léon Gérôme, *Portrait of Mlle. Durand*, 1853. Oil on canvas. Signed and dated. 50 x 34 inches. Mr. and Mrs. Joseph M. Tanenbaum, Toronto. Photo courtesy of H. Shickman Gallery, New York.

Gérôme also received substantial official patronage during the 1850s, including commissions for secular and religious decorations. One such commission, a 230-square-foot allegory of *The Age of Augustus* (Musée de Picardie, Amiens) for the Exposition Universelle of 1855, celebrated the coincidence of the Pax Romana and the birth of Christ, and prompted Gérôme to travel in order to study various ethnic types for inclusion. This he did in a sketching tour along the Danube and into the Balkans and Turkey. His large fee from the commission permitted further travel, and, in 1855–1856, he spent eight months in Egypt. As a result of this visit, and of six additional journeys to North Africa and the Near East, Gérôme adopted the ethnographic subjects that informed two-thirds of his artistic production. Although they were usually executed in Gérôme's Paris studio, with the assistance of props gathered on his travels and French models who, like his props, often appear in more than one painting, his Near Eastern images have been cited for their value as ethnographic record.[20]

Whether images from French or ancient history, classical or Near Eastern genre, Gérôme's meticulous tableaux display a consistent and distinctive concern with objective description and almost photographic finish. Almost all of his works tend to be relatively modest in size and gentle, rather than bombastic in mood. While his paintings are technically traditional, depending entirely upon

20. See Ettinghausen, "Jean-Léon Gérôme as a Painter of Near Eastern Subjects," in *Gérôme* (exh. cat., Dayton, 1972), pp. 16–26.

constructive methods advocated by the academy since the heyday of Jacques-Louis David (1748–1825), Gérôme was an innovative and prolific sculptor. In 1878, he made his debut as a sculptor at the Exposition Universelle and frequently showed sculpture at the Salons thereafter. His sculptural works make imaginative use of combined materials, such as ivory, tinted marbles, semiprecious stones, and polychromy, to convey an uncanny sense of verisimilitude. His sculptural works are, in a sense, three-dimensional embodiments of forms that appear in his paintings. Occasionally, they are even identical with some of his painted figures.

Conversely, Gérôme's paintings reflect his interest in sculpture. Sculpture is a frequent theme in his painted *oeuvre*, which includes such autobiographical works as *The End of the Seance* (fig. 12), which shows his model draping his plaster of *Omphale* (marble, Salon 1887; Mairie, Vesoul) with wet rags to keep it from drying out while the sculptor wrings out additional rags in a pail. In *The Artist and His Model* (1895; fig. 15), he shows himself working from a model on a plaster image of *Tanagra*, the embodiment of the Greek city which had produced realistic genre sculpture. Gérôme had shown his marble figure of *Tanagra* (Musée du Louvre, Paris), whose creation he depicts in this painting, in the Salon of 1890. Gérôme's paintings themselves, constructed tonally and then colored, often suggest tinted stone. As Gautier noted with reference to *The Cock Fight* (fig. 13), it is "a charming picture, which could have been taken for an antique colored bas-relief."[21]

Gérôme's paintings were not only admired for their technical finesse, but were considered entirely reflective of and appropriate to the scientific, objective concerns of his time. His extreme literalism, so antithetical to the optical Realism then being developed by Manet and the Impressionists, depended upon close analysis of *what* he saw, rather than *how* he saw. Gérôme's and other academic painters' taut, disciplined literalism has received little sympathetic scrutiny in the twentieth century, despite its close relationship to the concurrent interests of the Realist and Impressionist avant garde. Thus it is worth viewing through contemporary eyes. Such commentary as that offered by the American artist and critic Eugene Benson (1839–1908) is informative. Writing in the first volume of *The Galaxy* in 1866, Benson observed:

> . . . to-day, which is given to study, to travel, which is accurate, mechanical, unimpassioned, which cares nothing for military glory, which dreads revolution, which wishes to *know*, which exhalts knowledge and seeks for sensation, but is not poetic or heroic, is represented by Gérôme. Gérôme, to-day in France, the popular painter of France, is closest to the moral spirit and best shows the intellectual traits of his time.

21. Gautier quoted in Hering, *Gérôme*, p. 168.

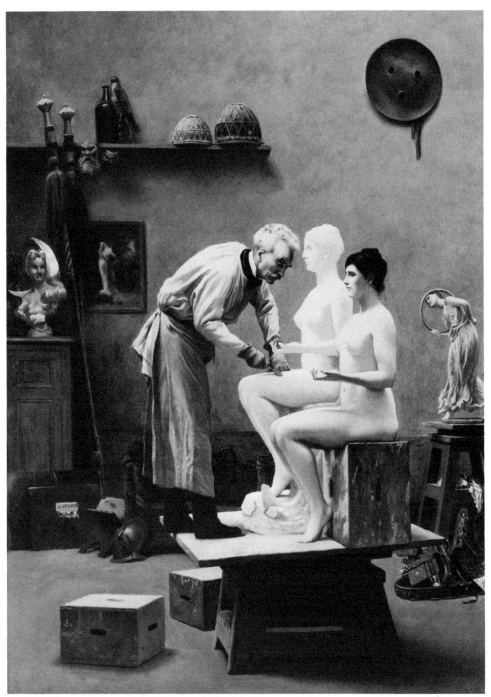

15. Jean-Léon Gérôme, *The Artist and His Model*, 1895. Oil on canvas. Signed. 20⅛ x 15⅛ inches. Haggin Collection, The Haggin Museum, Stockton, California.

. . . He investigates like an antiquarian; he is severe like the classicists; he is daring like the romanticists; he is more realistic than any other painter of his time, and he carries the elaboration of surfaces and the science of design further than any of his contemporaries. Like the modern mind, he travels, he explores, he investigates, and he tries to exhaust his theme. He labors to leave nothing unsaid, to cover the whole of his subject.[22]

Benson's article was the earliest major assessment of the master in an American publication, the first entry in an extensive American bibliography which reflected and encouraged Gérôme's popularity among American patrons and his unique appeal to art students. Among the most revealing entries in that bibliography are remarks by those students, who recorded their observations of his manner, his principles, and his influence in commemorative publications. While these remarks often emphasize recollections of personality, and often reflect the writer's efforts to dissociate himself from his teacher at a mature stage of his own development, they are nonetheless useful. Gérôme himself never compiled a complete statement of his principles of instruction, so his students' records and reminiscences, however personal and fragmentary, are essential clues. Written testimonials to Gérôme's influence also offset the lack of surviving student work by many of his most prominent American pupils, and support inferences that may be drawn about that influence from their later paintings.

All recollections agree that Gérôme's standards for his students' efforts as draughtsmen were extremely exacting, and they had to be met before he permitted them to paint. The ability to render plaster casts clearly, accurately, and volumetrically, with subtle control of tonal modulations—as Julian Alden Weir did in a charcoal drawing of a full-length classical cast of a male figure seen from behind (fig. 16)—was primary and fundamental to further training in drawing. Bunker's pencil drawing of a cast of the Parthenon "Illisos" (fig. 17), preserved from his period of study with Gérôme, is inscribed in the master's hand: *"Ces torses sont la base de l'éducation. Il faut être nourri sur ces choses-là dans la jeunesse."* Although students could "graduate" from drawing in the Ecole's gallery of casts to working from life in the atelier, cast drawing was practiced by all students one week per month. Thus, surviving drawings such as Weir's and Bunker's may come from a relatively mature moment in their development.

Once a student was allowed to enter the atelier to draw from life, Gérôme's criticism remained rigorous. According to one observer of the impact of his instruction, "No pupil left the studio for his life work without learning to draw the human figure accurately. No poor proportions, crude outlines, or vague shadows were permitted under Gérôme's vigilant eye."[23] The emphasis on accurate life

22. Benson, "Jean-Léon Gérôme," *The Galaxy* 1 (August 1866): 582.
23. Bowditch, *Brush*, p. 10.

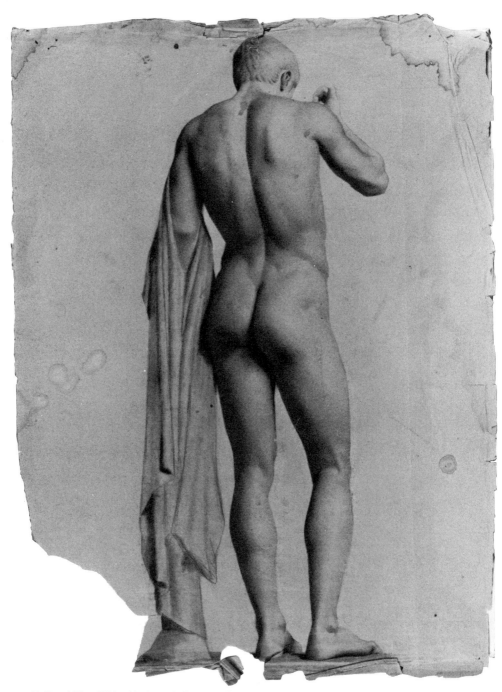

16. Julian Alden Weir, *Nude with Garment Draped on Arm*. Charcoal on paper. 24½ x 18 inches. Brigham Young University Art Museum Collection, Provo.

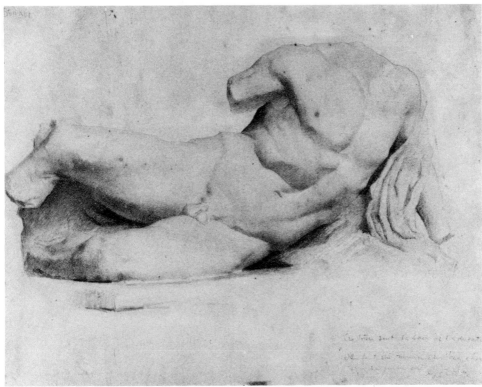

17. Dennis Miller Bunker, *A Torso*. Pencil on buff paper. 17⅝ x 23¾ inches. Isabella Stewart Gardner Museum, Boston.

drawing resulted in the fact that the number of students drawing from the model in the atelier far exceeded the number of those engaged in making painted studies.

Some of Gérôme's surviving drawings, as well as his monochrome oil study for *King Candaules* (1859; fig. 18), suggest that Gérôme advocated a technique by which major outlines of the model were first blocked in before the image was finished, part by part. The notes of one of his American pupils confirms this impression. Weir wrote to his brother that Gérôme

> makes his pupils practice blocking in and drawing in outlines with merely the principal shade, striving entirely for the action of the figure. If one does not get the exact portrait of the man, but has something good in the head, he will commend you. He believes in leading the student on slowly, not allowing him to finish up highly until he knows how to draw the figure well. Then by degrees he pushes one on in modeling and wants him to model and carry his figure as far as he possibly can, but not to attempt this until he becomes acquainted with the figure and knows what he is about,

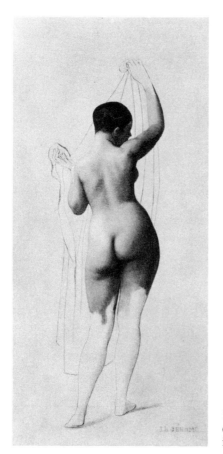

18. Jean-Léon Gérôme, *Nude, Study for King Candaules*, 1859. Oil on canvas. 15½ x 7⅞ inches. M. R. Schweitzer, New York.

otherwise he considers it as so much time that could be spent more profitably.[24]

Evidence of this working method appears in one of Weir's life drawings of a male nude, almost certainly done in Gérôme's studio (fig. 19). The overall pose of the striding figure appears to have been blocked in with relatively short strokes that create a generalized, angular outline. Having established the overall impression, Weir began to finish up the drawing part by part. Having fully modeled the head and chest of the figure, Weir then proceeded to shade the arms, one by one. He put aside the exercise after the raised right arm of the model had been moderately developed, but while the left arm was in transition from the initial sketch to higher finish. The model's legs, still only summarily sketched, were evidently left for last.[25]

24. Weir to John Ferguson Weir, Paris, 11 January 1874, quoted in Dorothy Weir Young, *The Life and Letters of J. Alden Weir* (New Haven, Connecticut, 1960), pp. 27–28. Charles Bargue, a pupil of Gérôme who wrote *Cours de Dessin* (Paris, 1868–1870) with Gérôme's advice, elaborates on the working procedure described briefly by Weir. See Doreen Bolger Burke, *J. Alden Weir, An American Impressionist*, (Newark, Delaware, 1983), pp. 49–50.

25. Another drawing is described similarly in Burke, *Weir*, pp. 54–55.

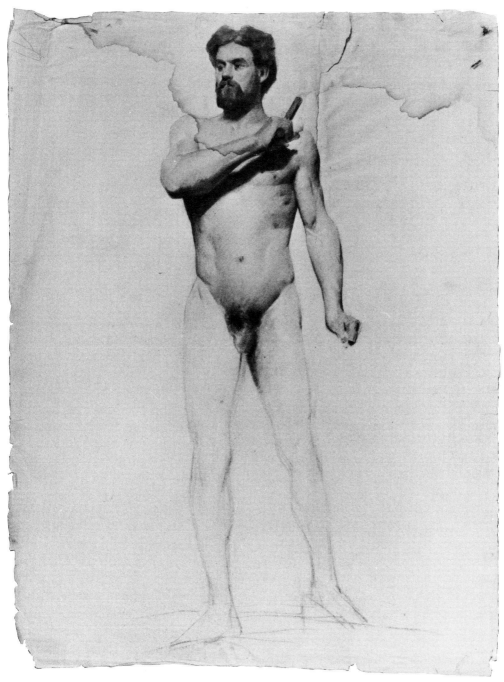

19. Julian Alden Weir, *Male Nude Preparing to Strike*. Charcoal on paper. 23⅞ x 18⁷⁄₁₆ inches. Brigham Young University Art Museum Collection, Provo.

One of the most prolific contributors to the American bibliography on Gérôme was Earl Shinn (1837–1886), who entered Gérôme's atelier in early November 1866, a week later than his Philadelphia compatriots, Eakins and Harry Humphrey Moore (1844–1926). Either because of failing eyesight or his Quaker family's antipathy to his career as an artist, Shinn never matured as a painter and no paintings by him are known. However, he became an influential critic, an invaluable recorder of and commentator on late nineteenth-century art and taste. Writing later under the pseudonym of Edward Strahan, Shinn offered sympathetic observations on Gérôme and his works in a number of ambitious publications, including the monograph published in New York in 1881–1883.[26] His first account of Gérôme (and his first professional publication) was a lively review of "Art Study in the Imperial School at Paris," which appeared in *The Nation* between April and July 1869. Although this five-part article contains a substantial record of the social life of the studio and of the American art student in Paris, Shinn concludes, "The true events of school life are the schooling and the advance; not the describable things, not the holidays and junketings, not the diversions and recreations I have attempted to portray. What is really the week's affair of the Beaux-Arts man is his 'academy.'"

Shinn recounts the making of the *académie* such as Weir's (fig. 19), the single-figure study from the live model, that was the central weekly studio obligation. The *académie* was drawn or painted, depending on the student's degree of advancement, and was full or half-length, depending on his vantage point in the crowded studio (see figs. 20 and 21). Shinn's account—which describes drawing but is equally applicable to painting—confirms the well-known fact that study of the nude was the essential Beaux-Arts exercise, the basis for almost all criticism within the school. However, Shinn also discloses a fundamental concern for literal, naturalistic rendering of the single-figure study, a concern that is at odds with general perceptions of academic training as emphasizing an ideal, rather than a natural approach. While a certain amount of idealization or contrivance was considered acceptable in formulating compositions, a student's failure to realize the actuality of appearance in a study from life was grounds for serious criticism. (This distinction was reiterated pithily in a letter from Weir to his brother: "There is considerable difference between making a study and composing a picture."[27] Weir's *Study of a Male Nude Leaning on a Staff* (fig. 22), executed in Gérôme's studio in 1876, is a typical painted *académie*, to which the artist added a sketchy glimpse of a painter at work at the lower right. It should

26. See note 17, above. See also, *idem., The Art Treasures of America*, 3 vols. (New York, 1879–1882), which notes the inclusion of paintings by Gérôme in almost every private collection outside of New England, and documents the prevailing American taste for French academic and Barbizon painting.

27. Weir to John Ferguson Weir, Paris, 15 August 1874, quoted in Burke, *Weir*, p. 56.

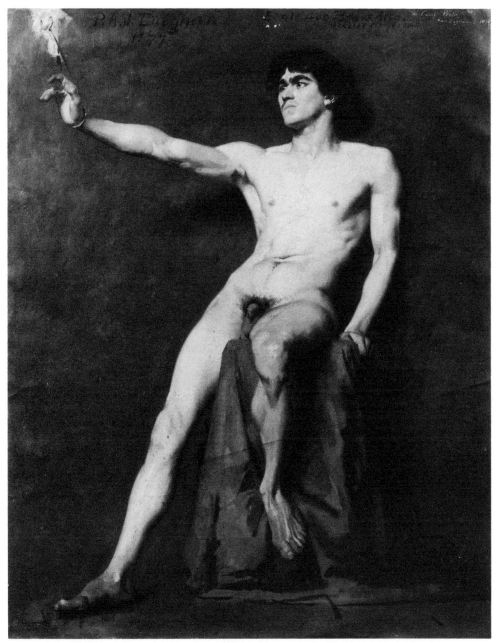

20. P. A. J. Dagnan-Bouveret, *Male Nude Study*, 1877. Oil on canvas. Signed and dated.
25½ x 31½ inches. Yale University Art Gallery, Gift of Julian Alden Weir.

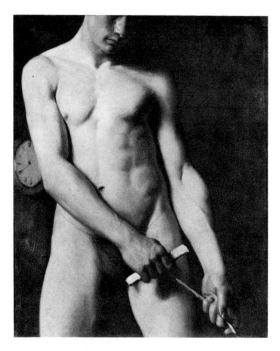

21. P. A. J. Dagnan-Bouveret, *Male Nude Study*, 1875. Oil on canvas. Signed and dated. 13 x 16 inches. Yale University Art Gallery, Gift of Julian Alden Weir.

be emphasized that students painted *compositions* under the roof of the Ecole only in competitions, such as that for the *Grand Prix de Rome*. While Gérôme gave out weekly compositional assignments for the students to sketch, their working up of compositions in paint was an activity to be undertaken in their own studios.)

According to Shinn:

> On Monday he hits the pose, which is always vigorously pronounced and spirited, on the model's part, when first assumed; the dash that may be thrown into the attitude while the figure is perfectly fresh can never be caught again if missed at the beginning. By Tuesday the artist has become absorbed in the complications of light and shade. On Wednesday the master comes, and perhaps rejects nearly everything that has been done, disfiguring and blotting the sketch from one margin to the other. The model, dropping upon his dais, may bear little resemblance to the elastic attitude of the drawing, and the student is accused of attempting to idealize. You have been trying to modify nature from your reminiscences of the antique; you have ennobled the head, braced the shoulders, etc. The study is altered, in the spirit of realism, until all the stark and pitiful ugliness of the model's lassitude is expressed. One of the difficulties of a life "academy" is that, although the example before you is a moving, changing object, now braced, now drooping, now turned to the right and now a little to the left, your

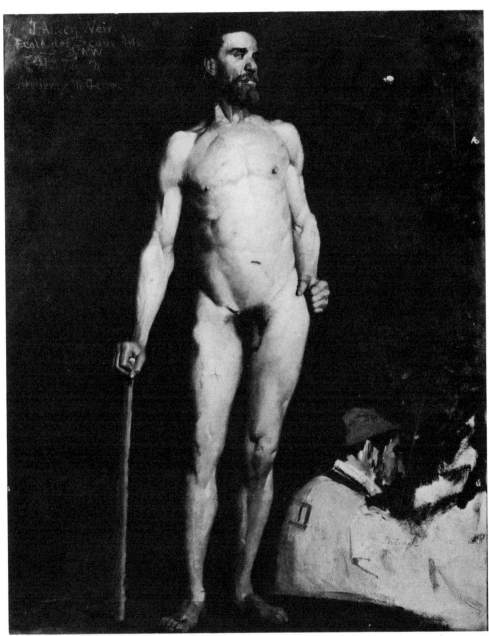

22. Julian Alden Weir, *Study of a Male Nude Leaning on a Staff*, 1876. Oil on canvas. Signed and dated. 35½ x 31½ inches. Yale University Art Gallery, Gift of Julian Alden Weir.

copy of it is expected to show all the purism of the photograph. If you were putting the same model into a historical picture, you would be expected to elevate the attitude and expression; and you would then begin to hear from your critics a great deal about the difficulty and responsibility of borrowing from nature, what to take and what to leave.[28]

Gérôme's commitment to scrupulous study of nature—especially of the anatomy of the nude—is evident as well in his studio dicta, "the compressed results of a life of study," which Shinn recorded. These dicta, which emphasize accuracy as well as grace, are entirely in accord with the visual traits of his paintings. They also indicate his respect for principles available for emulation in the art of the Old Masters, especially those within the classical tradition. Among the critiques offered by Gérôme during one studio visit, Shinn noted the following:

> Observe . . . your muscles are inlaid against one another. They are carpentered. There is something—*that* is not the vivacity of flesh. Go next Sunday to the Louvre and observe some of the drawings of Raphael. He does not use so much work as you, yet one feels the elasticity of his flesh, packed together of contractile fibres, based upon bone, and sheathed in satin. You tell me you will express that texture afterward. I tell you Raphael expressed it from the first stroke.

> Your color rages . . . ; that of the model is lambent. Besides, your figure is tumbling, it is not on its legs. I will save you your labor by telling you the simplest way of correcting this. Turn the canvas upside down and draw it over. The error is radical.

> You do not yet understand the continuity of forms in nature. You accent too highly. That is vulgarity. For instance: it appears to you that the internal and external *vastus* [a division of the quadriceps muscle], when gathered in at the knee, cause a break in the outline, like the cap of a pillar. Similarly, under the calf. You are deceived, and should use your eyes; the accent is not in the line, it is in the shading beside the line, and even there far more slightly than you think. Here again, the vein crosses the fore-arm. You make a hideous saliency. Nature never, absolutely never, breaks a line.[29]

Gérôme's emphasis on investigative observation and disciplined transcription of natural forms, especially the human figure, and on lucid compositional construction in his own paintings, affected many of his numerous American students, whatever their individual subject preferences. It was, in fact, Gérôme's

28. Shinn, "Art Study in the Imperial School at Paris; a Story," *The Nation* 9 (22 July 1869): 68. Gérôme's emphasis on correct imitation of nature and his impatience with generalized rendering are elaborated in his preface to Hering, *Gérôme*, pp. v-vii.

29. Shinn, "Art Study," *The Nation* 9 (6 May 1869): 352.

fluid approach to subject matter, his ability to explore a variety of times and places with an indefatigible artist-reporter's eye, that made him so attractive a teacher to a broad range of American pupils. As Shinn noted in the early 1880s, "A complete list of Gérôme's paintings would almost indicate that his alert and fertile mind had made a foray into nearly every province in which the curious and questioning modern intellect is interested, and had brought back from each a clever canvas to bear witness to his skill as a painter, and to the extent of his reading."[30] Some of Gérôme's American pupils, such as Frederick Arthur Bridgman, pursued their careers abroad and closely emulated his subject interests. Others, such as Thomas Eakins, consistently transformed his preferences, adapting them to the thematic resources of his American milieu.

30. Shinn, *Gérôme*, unpaginated.

Thomas Eakins: a Methodological Model

THOMAS EAKINS (1844–1916) has been the subject of considerable scholarly attention, in contrast to many of his more cosmopolitan American contemporaries, and his works are quite well known and accessible. It is, therefore, inviting to explore his relationship with Gérôme and with Gérôme's work at length. By doing so, we may point up the variety of strategies that may be used to evaluate the impact of a teacher upon his pupils. These strategies, not always available due to the loss of works and documents, include considering adoption of general ideals; discovering reiterations of specific motifs, poses, and compositional devices; evaluating absorption of thematic concerns, which may be directly imitated, "domesticated," or otherwise transformed; and noting assimilation of working procedures.

Eakins's desire to pursue Parisian training may have been stimulated by his contact with Christian Schussele (1824–1879), a painter born in Alsace and reportedly trained by Delaroche and Yvon before his emigration to Philadelphia in 1847. His friendship with Lucien Crépon, a French painter who had lived in Philadelphia and studied at the Pennsylvania Academy of the Fine Arts before his return to France, has also been mentioned as a spur to his decision to study in Paris. Eakins may have been attracted specifically to the straightforward documentary quality of Gérôme's *Egyptian Recruits Crossing the Desert* (1857; fig. 23), which was shown at the Pennsylvania Academy three times during his school years there in the early 1860s. Depicting conscripts for the army or for work on the Suez Canal, the painting is remarkable for its lack of sentimentality, its finely detailed figures, its convincing atmosphere, and especially for its unpretentiousness by contrast with most European academic works then to be seen in Philadelphia.[31]

Eakins's correspondence from Paris after his enrollment in Gérôme's atelier in October 1866 suggests the beginnings of a durable respect for his teacher. He wrote to his father in the second week:

31. The influence of Lucien Crépon is mentioned in Lloyd Goodrich, *Thomas Eakins* (Cambridge, Massachusetts, 1982), vol. l, p. 17. Gerald M. Ackerman, "Thomas Eakins and His Parisian Masters Gérôme and Bonnat," *Gazette des Beaux-Arts*, series 6, 73 (April 1969): 235–236, notes the likely attraction of *Egyptian Recruits*. The work seen by Eakins and illustrated here is a smaller replica of the painting that Gérôme showed in the Salon of 1857, which is now owned by the Coral Petroleum Company, Houston; Gerald M. Ackerman to author, 14 October 1983.

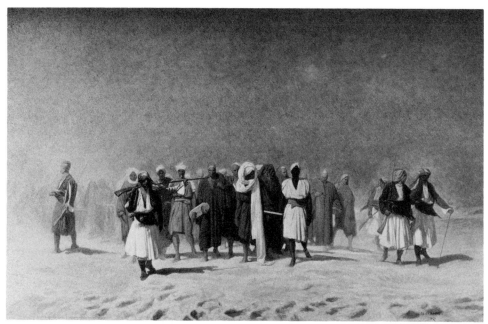

23. Jean-Léon Gérôme, *Egyptian Recruits Crossing the Desert*, 1857. Oil on panel. Signed and dated. 14⅞ x 24¼ inches. Mr. and Mrs. Joseph M. Tanenbaum, Toronto.

> The studio contains some fine young artists, and it is an incalculable advantage to have all around you better workmen than yourself, and to see their work at every stage. . . . I will never forget the day that Gerome criticised my work. His criticism seemed pretty rough, but after a moments consideration, I was glad. I bought Geromes photograph that very night. . . .
>
> Gerome comes to each one, and unless there is absolute proof of the scholar's having been idle, he will look carefully and a long time at the model and then at the drawing, and then he will point out every fault. He treats all alike good and bad. What he wants to see is progress. Nothing escapes his attention. Often he draws for us. The oftener I see him the more I like him.[32]

That Eakins felt himself to be surrounded by better workmen is significant, as it was those better workmen who became, in effect, their colleagues' instructors at times. Not only were the visits of the *chefs d'atelier* only semi-weekly, but Gérôme, in particular, was often absent from the Ecole because of travel.[33]

32. Quoted in Goodrich, *Eakins*, vol. 1, p. 21. All other letters by Eakins from Paris (with their quirky punctuation) are quoted from this source, pp. 23–53, *passim*.

33. For example, a North African *safari* from January to April 1868 kept Gérôme away from the Ecole, where his close friend and artistic alter ego, Gustave Boulanger (1824–1888), served as

As he had drawn from antique casts at the Pennsylvania Academy for five years before going to Paris, Eakins was excused from that rudimentary exercise. However, he was required to continue drawing—albeit from life—for five months in Gérôme's atelier before being permitted to paint. He wrote home in March 1867: "Last time he made no change in my work, said it was not bad, had some middling good parts in it, but was a little barbarous yet. If barbarous and savage hold the same relation to one another in French that they do in English I have improved in his estimation. . . . 5 months! Only once he told me I was going backwards & that time I had made a poetical sort of outline."

Finally on 21 March 1867, Eakins reported, "Gerome has at last told me I might get to painting & I commence Monday." Two weeks later he told his parents: "I am working in color now and succeed in getting off some beastly things but hope to do better." By the fall of 1867, Eakins had decided that his difficulties in mastering painting might be best resolved by work away from the Ecole's classroom, with only occasional criticisms from Gérôme. Despite his experience in drawing from life, Eakins appears to have found painting from life difficult because of Gérôme's emphasis on laying in only the principal shades at first and leaving out the more subtle half tones until the students were more advanced. Eakins found rendering inanimate colored objects according to this formula simpler than rendering flesh. He decided to devote himself to such objects, and to avoid the life class until he felt more comfortable in handling paint. Having rented his own studio, he wrote home on 20 September 1867:

> Gerome told me before I left to paint some bright colored objects; lent me some of his Eastern stuffs which are very brilliant & I am learning something from them, faster than I could from the life studies. The colors are strong & near the ends of my scale of colors, such high & such low notes & this has taught me a good many things that I might not have paid attention to, if I had only been painting flesh, where the colors are not strong but very delicate & clean. I remember many a trouble that I have got into from trying to play my tunes before I tuned my fiddle up.

By the time he began to consider his Parisian training finished, Eakins had ambivalent feelings about the enterprise as a whole and about his teacher, although he had executed some creditable figure studies such as that of a bust of a nude man (1867–69; fig. 24). In late autumn 1869, he wrote to his father:

> For a long time I did not hardly sleep at nights, but dreamed all the time about color & forms & often nearly always they were craziness in their queerness. So it seems to me almost new & strange now, that I do with

his substitute. Gérôme's absence may have prompted Eakins's enrollment in the Ecole atelier of the sculptor Augustin Alexandre Dumont (1801–1884) at this time.

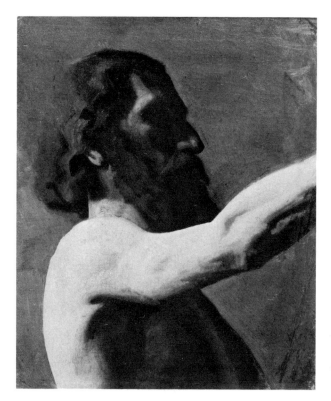

24. Thomas Eakins, *Bust of a Man*, 1867–69. Oil on canvas. 21½ x 18¼ inches. Philadelphia Museum of Art, Given by Mrs. Thomas Eakins and Miss Mary A. Williams.

great ease some things that I strained so hard for & sometimes thought impossible to accomplish. I have had the benefit of a good teacher with good classmates. Gérôme is too great to impose much, but aside his over-throwing completely the ideals I had got before at home, & then telling me one or two little things in drawing, he has never been able to assist me much & oftener bothered me by mistaking my troubles.

These last, negative remarks by Eakins have encouraged scholars to dimin-ish the generally enthusiastic tone of his letters from Paris. These writers have also discounted the fact that, even after his return home in 1870, Eakins carried on a friendly professional correspondence with Gérôme, seeking his advice on paintings and enlisting his aid in conveying them to dealers and Salon juries. Scholars have rarely addressed the question of Gérôme's actual influence upon Eakins. They do acknowledge that seventeenth-century Spanish painting, which Eakins saw in Madrid just before his return to Philadelphia, was crucial to the development of his style. However, they have ignored the likelihood that Eakins's interest in Spanish art developed under the influence of his second Pari-sian painting teacher, Léon Bonnat (1833–1922); the probability that Eakins

was referred to Bonnat by Gérôme; and the fact that Gérôme himself was enthusiastic about the art of Velasquez.

In a seminal article on Eakins's relationship with his Parisian teachers, published in 1969, Gerald M. Ackerman noted some obvious reiterations by Eakins of motifs that appear in the works of Gérôme.[34] He persuasively suggested that the arrangements of Gérôme's *Pifferari* (fig. 10)—of which Eakins had acquired a photograph in Paris—are restated in the American's *Street Scene in Seville* (1870; Coll. Mrs. John Randolph Garrett, Sr., Roanoke, Va.), his earliest surviving multi-figured composition. He proposed that Gérôme's exotic genre images of the Near East—his *Draughts Players* (1859; The Wallace Collection, London), *Bashi-Bazouk Singing* (1859; Walters Art Gallery, Baltimore), and his *Arab Chief* (n.d.; Philadelphia Museum of Art)—inform the arrangements of later paintings by Eakins—his *Chess Players* (1876; Metropolitan Museum of Art, New York), *Home Ranch* (1892; Philadelphia Museum of Art), and *Frank Hamilton Cushing* (1894 or 1895; Thomas Gilcrease Institute of American History and Art, Tulsa), respectively. With the exception of *Arab Chief*, all the paintings by Gérôme that Ackerman noted in this connection were reproduced by Shinn in his monograph of 1881–1883, and in Goupil photogravures even earlier.

Additionally, Ackerman remarked on adaptations of Gérôme's gladiatorial scenes in the amphitheatres of Eakins's Gross and Agnew clinics (1875; Jefferson Medical College, Thomas Jefferson University, Philadelphia, and 1889; University of Pennsylvania School of Medicine, Philadelphia), and in his late fight images, such as *Between Rounds* (1899; Philadelphia Museum of Art) and *Salutat* (1898; fig. 25). He specifically compared this last work with Gérôme's *Ave Caesar* (fig. 5), as it shares a Latin title and depicts analogous activities and poses. Ackerman's argument is supported by the fact that Gérôme's painting appeared in the Exposition Universelle of 1867, during the course of Eakins's studies in Paris and was also reproduced in Shinn's monograph. A recent study added that Eakins "emphasized the similarity of the modern professional boxer to the gladiator of old by the sculptural treatment of the boxer's figure as he salutes the cheering crowd and by the inscription that he carved on the frame of the painting: 'Dextra Victrice Conclamantes Salutat.'"[35]

Ackerman also posited that *John Biglin in a Single Scull* (1873; Metropolitan Museum of Art, New York), which Eakins repainted after receiving criticism

34. Ackerman, "Eakins," *Gazette des Beaux-Arts*, series 6, 73 (April 1969): 237–256, *passim*. Kathleen A. Foster expanded upon Ackerman's observations in "Philadelphia and Paris: Thomas Eakins and the Beaux-Arts," manuscript, History of Art Department, Yale University Graduate School, 1972.

35. Darrel Sewell, *Thomas Eakins, Artist of Philadelphia* (exh. cat., Philadelphia Museum of Art, 1982), p. 33.

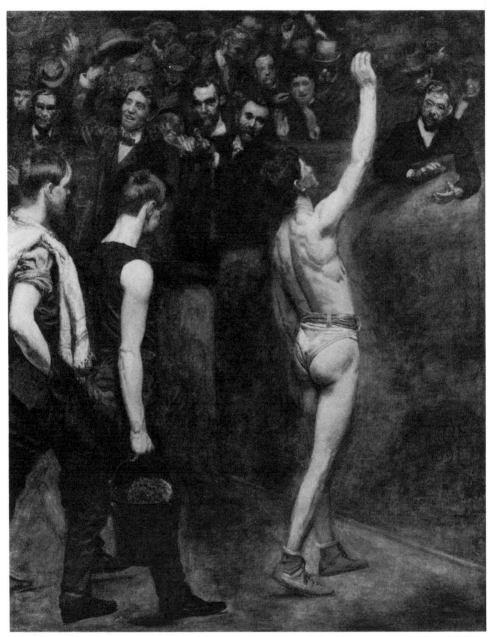

25. Thomas Eakins, *Salutat*, 1898. Oil on canvas. Signed and dated. 49½ x 39½ inches. Addison Gallery of American Art, Phillips Academy, Andover, Massachusetts.

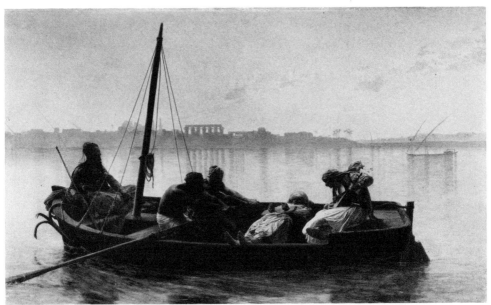

26. Jean-Léon Gérôme, *The Prisoner*, 1861. Oil on panel. Signed and dated. 18⅞ x 30¾ inches. Musée des Beaux-Arts, Nantes.

from Gérôme, reiterates the pose of the rower in *The Prisoner* (1861; fig. 26), one of Gérôme's most celebrated paintings, of which Eakins appears to have had a photograph. An even more persuasive case could be made for a relationship between one of Eakins's more ambitious sculling pictures, *The Biglin Brothers Turning the Stake* (1873; fig. 27), for example, and *The Prisoner* or *Excursion of the Harem* (1869; fig. 28), which Gérôme painted and showed in the Salon during the last year of Eakins's study in Paris. In any comparison between a work by Eakins and one by Gérôme, however, the narrative and dramatic quotients seem reduced in the work of the pupil. Typically, Gérôme chooses a somber theme for such a work as *The Prisoner*, and fills the scene with characters in varied and theatrical poses: a stoical victim whose legs are bound with ropes and whose hands are held in wooden stocks, a taunting musician in the stern of the ship, a stolid officer in the prow, and straining Nubians who pull the oars. Eakins, by contrast, builds an eloquent composition out of friends, not professional models, in the *Biglin Brothers*, emphasizes the grace and ease of their activity, and modifies the sense of drama and rigor in their race.

Despite these differences in content, both artists' river paintings share careful arrangements of forms and their interrelationships, a concern with meticulously observed and recorded anatomical and costume detail, glowing light emanating from the horizon, and refined surfaces. In describing *Excursion of the Harem*, Shinn noted enthusiastically:

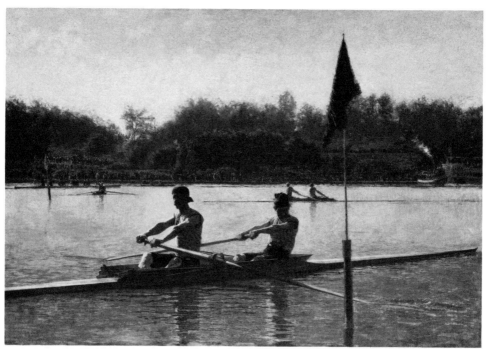

27. Thomas Eakins, *The Biglin Brothers Turning the Stake*, 1873. Oil on canvas. Signed and dated. 40¼ x 60¼ inches. The Cleveland Museum of Art, Hinman B. Hurlbut Collection.

28. Jean-Léon Gérôme, *Excursion of the Harem*, 1869. Oil on canvas. 47½ x 70 inches. The Chrysler Museum, Norfolk, Gift of Walter P. Chrysler, Jr.

The painter has traced with keen enjoyment the long, sweeping curves of the boat, reversed by the reflection in the water below, and continued and completed by the larger vessels moored on the bank. . . . but it is to be observed that the presence of [the] occupants is highly necessary. . . . If we take away the crew of M. Gérôme's boat, or even any one of them, his skilful composition goes to pieces at once. Even the folds of the drapery of the two figures at the ends, falling below the outline of the boat, are of the utmost importance, and the steersman could not possibly hold his oar at any other angle without great aesthetic damage, so arbitrary are the rules of the eye![36]

This account of measured perfection recalls descriptions of Eakins's boating scenes of the early 1870s, which often note their deliberateness, the control of their arrangements and light, their "tension between observed reality and abstract composition."[37]

Though not noted by Ackerman, Eakins's academic tendencies are also clearly evident in such works as *The Swimming Hole* (1884–1885; fig. 29), a classical composition which depends upon a stable pyramid, reminiscent of a temple pediment, to organize the informal revelries of a series of male nudes into a formal sequence of motion: reclining, rising, standing, diving, swimming back to shore. The degree to which Eakins choreographs his bathers' activities in this painting is confirmed by consultation of his well-known candid photographs of his students at the site. These photographs lack entirely the geometric compositional armature and the allusions to individual *académies* that are so obvious in the finished painting. Fascinating, too, are the analogies between the pyramidal sequence of poses in *The Swimming Hole* and those which Eakins recorded in motion photographs that he made with the Marey wheel in the mid-1880s.[38] This coincidence of traditional and modern references—of an academic armature conjoined with the most modern, scientifically recorded actualities—is, indeed, the essence of Eakins's art and the key to his strength and enduring interest as a painter.

As Ackerman observed, Eakins's rare excursions into historical subject matter also suggest a residual influence from his teacher. His arcadian images of the early 1880s recall the idyllic visions of antique life that were the benchmark of Gérôme's "neo-Grec" style. His unfinished *Phidias* (1890; Private Collection) shows the Greek sculptor—Gérôme's greatest artistic hero—studying live athletes and horses for the Parthenon frieze, drives home the obvious point that he

36. Shinn, *Gérôme*, unpaginated.
37. Sewell, *Eakins*, pp. 15–19.
38. See, for example, *A man jumping horizontally*. Marey wheel photograph by Eakins, with his notations, 1885. Hirshhorn Museum and Sculpture Garden, Smithsonian Institution, Washington, D.C.; reproduced in Goodrich, *Eakins*, vol. 1, p. 274.

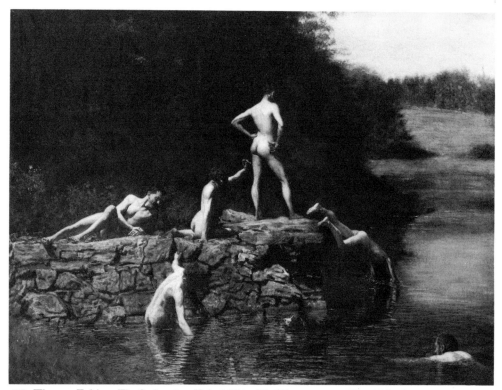

29. Thomas Eakins, *The Swimming Hole*, 1884–85. Oil on canvas. 27 x 36 inches.
The Fort Worth Art Museum.

did not work from classical casts, and posits a commitment to study from nature even among artists of the most profound classical tendencies. Eakins's *William Rush* series constitutes an American equivalent of the numerous historical images of artists in their studios that were produced throughout the nineteenth century by French artists of varying stylistic affiliations, including Gérôme, whose now unlocated *Rembrandt Etching a Plate* (Salon 1861) appeared at the Exposition Universelle of 1867 (see also figs. 12 and 15). The careful research that Eakins carried out for the pyramidally ordered first painting (1876–77; Philadelphia Museum of Art), the autobiographical quality of the unfinished last painting (1907–08; fig. 30), and the evidence of an interest in sculpture to which the entire Rush series attests, also parallel Gérôme's works and attitudes, as does Eakins's own work as a sculptor.

Eakins made sculpted versions of such paintings as *Spinning* (1881; Metropolitan Museum of Art, New York), as Gérôme had done when he reproduced the main combat group from his *Pollice Verso* (1874; fig. 31) in bronze for display at the Exposition Universelle of 1878. Like Gérôme, Eakins used wax maquettes, as well as photographs, for reference, and made extensive preliminary

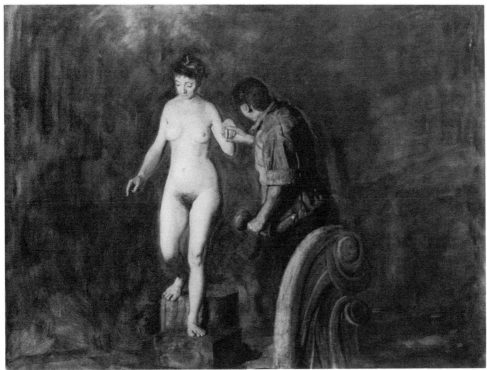

30. Thomas Eakins, *William Rush and His Model*, 1907–08. Oil on canvas. Signed. 35¼ x 47¼ inches. Honolulu Academy of Arts, Purchase, September 1947.

studies, including detailed perspective drawings and oil sketches, for his paintings. Additionally, he recommended that his students work in sculpture, as he himself had done in Paris, to avoid loss of volume in painted images. Eakins's profound interest in human and equine anatomy also parallels that of his teacher.

Eakins's practice as a painter and teacher, and his correspondence both during and after his years as a student, indicate his respectful appreciation of Gérôme, whom he called the greatest painter of the nineteenth century and in whose approbation he revelled.[39] Contemporary observers of Eakins's works also remarked on their connection to French ideals. When, for example, *Pushing for Rail* (1874; Metropolitan Museum of Art, New York) and *Starting out after Rail* (1874; Museum of Fine Arts, Boston) appeared in the Salon of 1875, the critic for the *Revue des Deux Mondes* remarked: "These two canvases . . . resemble photographic prints covered with a light watercolor tint to such a degree that one asks oneself whether these are not specimens of a still secret industrial process, and that the inventor may have maliciously sent them to Paris to upset M.

39. Goodrich, *Eakins*, vol. 1, p. 186.

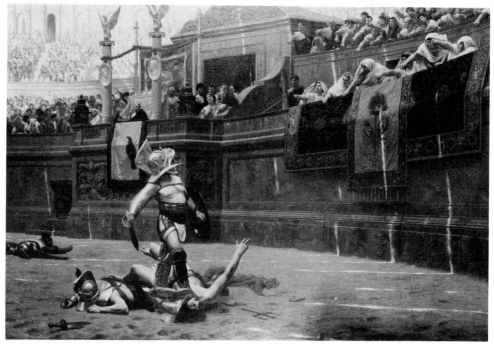

31. Jean-Léon Gérôme, *Pollice Verso*, 1874. Oil on canvas. Signed. 38 x 58¾ inches. Phoenix Art Museum, Museum Purchase.

Detaille and frighten the *école française.*"[40] Reviewing Eakins's sailing, hunting, and baseball scenes in the 1875 exhibition of the American Society of Painters in Watercolor, Shinn commented: "The most admirable figure-studies, however, for pure natural force and virility, are those of Mr. Eakins, in which the method of Gérôme is applied to subjects the antipodes of those affected by the French realist."[41]

Despite such contemporary acknowledgments of Eakins's debt to academic ideals, Ackerman was the first art historian to view his relationship with Gérôme sympathetically. This is the product of the place of Eakins scholarship in American art history in general. After a decade of profound neglect after his death in 1916, Eakins attracted the attention of scholars interested in the most "American" qualities that could be perceived within the generally cosmopolitan American painting of the late nineteenth century. The fact that Eakins had so convincingly domesticated academic subject matter, turning from the Seine and the Nile to the Schuylkill, made him susceptible to interpretation as a "purely American"

40. Quoted in Sewell, *Eakins*, p. 25. It might be noted that Eakins's 1875 Salon contributions were actually selected by Gérôme from Goupil's stock when Eakins's *envois* from Philadelphia failed to arrive in time. See Goodrich, *Eakins*, vol. 1, pp. 118–119.

41. Quoted in Sewell, *Eakins*, p. 31.

painter. Because of his subject preferences, he could be described as untainted by French art and could be detached from the pervasive cosmopolitan impulses of his time. His unquestionable strength as an artist, the fact that he is in many ways the more persuasive and more interesting artist than any of his teachers, prompted his adoption by those who sought a "native" stream in late nineteenth-century American painting.

A number of other pupils of Gérôme, who enjoyed much higher contemporary acclaim, have fared much less well than Eakins in the twentieth century. These include exotic genre painters, such as Bridgman; classical idealists, such as Blashfield, Kenyon Cox, Will Hicok Low, Wyatt Eaton, and Thayer; other domesticators of academic ideals, such as George deForest Brush and Douglas Volk; and academic artists with later Impressionist tendencies, such as Weir, Bunker, and Paxton. Each of these artists is considered in one of the three sections that follow, along with Edwin Lord Weeks, who appears to have developed his successful career as an orientalist under the influence and with the informal counsel of Gérôme. The fact that a number of these artists might have been treated in more than one section attests to their emulation of Gérôme's own fluid approach to subject matter.

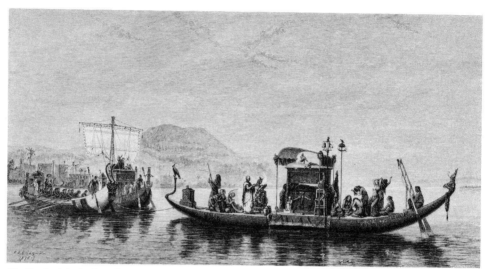

32. Frederick Arthur Bridgman, *The Burial of a Mummy on the Nile*, Salon 1877. Whereabouts unknown. Photo: *Art Journal* 4 (August 1878): 228.

In the Footsteps of Gérôme:
American Orientalists and Classical Idealists

FREDERICK ARTHUR BRIDGMAN (1847–1928) so fully imitated his teacher that critics enthusiastically remarked that his painting, *The Burial of a Mummy on the Nile* (Salon 1877; fig. 32), might have been signed by Gérôme himself.[42] While thus acclaimed in his own time, Bridgman was of no interest to twentieth-century scholars seeking reassuring "native" impulses in the late nineteenth century. Rather than suffering from interpretation across a filter of cultural nationalism, as Eakins has, Bridgman was simply ignored. Born in Tuskeegee, Alabama, Bridgman studied at the Brooklyn Art School and the National Academy of Design while he was apprenticed to the American Bank Note Engraving Company, New York, in 1864 and 1865. Going to France in 1866 at the age of nineteen, he began four years of study in Gérôme's atelier in February 1867.

Even before undertaking formal training in Paris, Bridgman manifested an interest in exotic subject matter that was resonant with that of his teacher. He spent the summer of 1866 in the company of a group of American artists who were investigating the peasant subjects available in the Breton village of Pont-Aven. The popularity of summer work in Brittany among American academic painters suggests that they found there images as picturesque to them as those of North Africa and the Near East were to their teachers, but available in a more accessible and affordable setting. Bridgman's *American Circus in Brittany* (1869–1870; Nelson Holbrook White, Waterford, Connecticut), for example, may be considered a more local, but still exotic counterpart of Gérôme's *Ave Caesar*. For all their exoticism, Breton peasants were yet familiar in relation to rural types whom American artists knew at home and whom they might adopt as subjects upon their return.[43]

Bridgman expanded his repertoire of peasant themes by summer travel in the Pyrenees in 1872, and followed in the footsteps of his teacher in Morocco and

42. Parisian critic Albert Wolff's review of the Salon of 1877, *Le Figaro*, quoted in *The American Register*, and reprinted in Clara Erskine Clement and Laurence Hutton, *Artists of the Nineteenth Century and Their Works* (Boston and New York, 1879), p. 94.

43. For a consideration of American academic painters' pursuit of Breton subjects, see David Sellin, *Americans in Brittany and Normandy, 1860–1910* (exh. cat., Phoenix Art Museum, 1982).

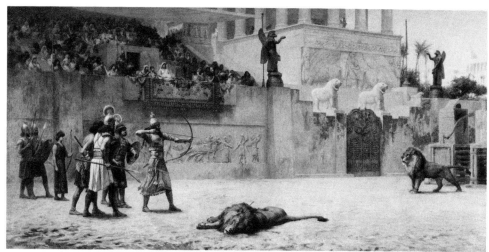

33. Frederick Arthur Bridgman, *Diversion of an Assyrian King*, Salon 1878. Oil on canvas. Signed. 44½ x 92 inches. Jerrald Dillon Fessenden, New York.

Algeria that fall and winter. There, and in Egypt in 1873, Bridgman discovered for himself the North African types who were to dominate his paintings during the remainder of his career. These types appear in both contemporary settings and in historical scenes. In *The Burial of a Mummy*, which is obviously resonant with Gérôme's *The Prisoner* and *Excursion of the Harem* (figs. 26 and 28), Bridgman recreates with loving attention to detail the elaborate obsequies in two heavily laden boats on the Nile. The painting was so successful upon its exhibition in the Paris Salon of 1877 as to gain the artist a third class medal. When Bridgman showed it the following year in the Exposition Universelle, together with another North African subject, he received a second class medal and was named a Chevalier of the Legion of Honor. Bridgman's *Diversion of an Assyrian King* (fig. 33), which he showed in the Salon of 1878, recalls the arena-floor perspective and gladiatorial allusions of Gérôme's *Ave Caesar* (fig. 5). His image of *An Interesting Game* (1881; The Brooklyn Museum) reiterates his teacher's numerous portrayals of draughts players (including the version of 1859 in The Wallace Collection, London, which was shown in the Exposition Universelle of 1867). His *Aicha, A Woman of Morocco* (1883; The Newark Museum) invokes the spirit of Gérôme's many paintings of exotic *almehs*. In light of the extreme approbation that greeted Gérôme's works in the late nineteenth century, it is not surprising that one of his most unabashed American disciples should have enjoyed substantial popularity and patronage in both the United States and in France, where he resided until his death.

While Bridgman's paintings owe a considerable debt to those of Gérôme, they are often distinguished, as are those of Eakins, by a somewhat freer and

more "painterly" style. This is quite evident in the *Diversion of an Assyrian King*. George William Sheldon, commenting on Bridgman's work in 1888, attributed this to the influence of another French orientalist, Eugène Delacroix (1798–1863).[44] In the case of Eakins, painterly tendencies are linked to his brief period of study with Bonnat in 1869, and to his sympathy, stimulated by Bonnat's allegiances, for seventeenth-century Spanish painting.

Edwin Lord Weeks (1849–1903) was also a student of Bonnat, and, like Eakins, hybridized that master's style with principles learned from Gérôme. Although Weeks was an immensely popular and prolific American expatriate painter, the details of his career are obscure and confusing. For example, no formal study prior to that which he undertook in Paris is recorded. With reference to his training in Paris, almost all published sources indicate that he worked with Gérôme, as well as with Bonnat. However, Weeks referred only to Bonnat as his teacher in the Salon catalogues that record his almost annual contributions between 1878 and 1900. The Salon catalogues of 1898 and 1899, and that of the Exposition Universelle of 1900, add that he was a student of the Ecole des Beaux-Arts, but he does not appear in the matriculants' registers. Correspondence preserved in the Ecole's archives includes a letter from Gérôme authorizing Weeks to enter his atelier on 22 September 1874.[45] While formal inscription does not appear to have followed—Weeks's name does not appear in the atelier register—there is every likelihood that he enjoyed private criticism from Gérôme, and developed his mature style very much under Gérôme's influence.

Inclined toward exotic subjects and locales by travel in Florida, South America, and North Africa even before undertaking study in Paris, Weeks would certainly have found a sympathetic mentor in Gérôme. Residence in Tangiers in 1878 and an important trip to India in 1882–1883 reinforced and expanded his commitment to exotic genre. Weeks's *Street Scene in the East* (n.d.; fig. 34) shares with Gérôme's *Saddle Bazaar* (1883; fig. 35) an obliquely viewed, meticulously detailed and intimate architectural corner populated by carefully investigated animals and Near Eastern types.

In contrast to these somewhat "painterly" North African images of the early 1880s, Weeks's later Indian scenes reflect a gradual rejection of the stylistic tendencies associated with Bonnat. These works, which dominate his Salon contributions after 1884, reveal instead Weeks's consistent devotion to a meticulous linear technique very similar to that of Gérôme. For example, Weeks's very ambitious Salon painting of 1885, *The Last Journey, Souvenir of the Ganges, Benares* (fig. 36), reiterates both the morbid content and the careful arrangements of Gérôme's *The Prisoner* (fig. 26) and Bridgman's *The Burial of a*

44. Sheldon, *Recent Ideals of American Art* (New York, 1888), p. 12.
45. Archives Nationales, Paris, Archives de l'Ecole Nationale Supérieure des Beaux-Arts, *Dossiers individuels des élèves. Série antérieure au 31 décembre 1893* (AJ52:273, Weeks).

34. Edwin Lord Weeks, *Street Scene in the East*. Oil on canvas. Signed. 28⅞ x 23¾ inches. National Museum of American Art, Smithsonian Institution, Washington, D.C., Harriet Lane Johnston Collection.

35. Jean-Léon Gérôme, *Saddle Bazaar*, 1883. Oil on canvas. Signed. 32 x 25⅝ inches. Haggin Collection, The Haggin Museum, Stockton, California.

36. Edwin Lord Weeks, *The Last Journey, Souvenir of the Ganges, Benares*, Salon 1885. Oil on canvas. Signed. 78½ x 117½ inches. Stuart Pivar, New York.

Mummy (fig. 32). As Weeks described the episode in the Salon catalogue: "Two Hindu Fakirs are making their pilgrimage to the holy city of Benares. As one of them is on the verge of death, his comrade rushes him across the hallowed river so that he can draw his last breath on the sacred shore [my translation]." When Weeks showed *The Last Journey* again at the Exposition Universelle of 1889, together with four other images of Indian genre, he was awarded a gold medal.

Weeks's painted account of *The Great Mogul and His Court Returning from the Great Mosque at Delhi, India* (c. 1886; fig. 37) is uncannily photographic in its precision, in the manner of Gérôme's *Egyptian Recruits* (fig. 23). Weeks's working methods emulated Gerome's as well. As a contemporary commentator, remarking on Weeks's excursions to the east, noted,

> . . . he conscientiously filled his portfolio with sketches and studies, and his head with impressions and souvenirs, while forebearing to paint 'pictures.' When he returns to his European studio he is enabled to put all these impressions and studies together and produce elaborate compositions that apparently have been painted from nature and art in the blazing sushine of Jetnan or Delhi. . . . At present Mr. Weeks occupies a handsome studio in

37. Edwin Lord Weeks, *The Great Mogul and His Court Returning from the Great Mosque at Delhi, India*, c. 1886. Oil on canvas. 33⅝ x 54¼ inches. Portland Museum of Art, Portland, Maine, Gift of Miss Marion Weeks in memory of Dr. Stephen Holmes Weeks, 1914.

Paris, crowded with the trophies of his travels, by the aid of which and the atmosphere which fills such an interior, he is enabled to conjure up again, on the banks of the Seine the life of the Ganges and the Jordan.[46]

Despite Gérôme's devotion to orthodox academic techniques and Bonnat's to richer surfaces in the tradition of Velasquez and Ribera, the two artists were in personal and professional sympathy. Bonnat, in fact, had accompanied Gérôme on a trip to Egypt and Asia Minor in 1868. In addition to this shared experience, they shared a number of American pupils. Edwin Howland Blashfield (1848– 1936) recalled that, upon his arrival in Paris, Gérôme agreed to accept him as a pupil, despite the fact that his prior training in Boston had been minimal. However, he counseled him that he would have to undergo "three months at least of routine formalities before [he] can enter the government school. You must not lose time," Gérôme advised. "Go to Bonnat until then; his is an open school *(atelier indépendant)*, and there is no better man in Europe to teach you."[47] Blashfield followed Gérôme's suggestion, enrolling in Bonnat's atelier in 1867

46. "Edwin Lord Weeks," *The Art Interchange* 30 (April 1893): 95–96.
47. Blashfield, "Léon Bonnat," in John C. Van Dyke, ed., *Modern French Masters* (New York, 1896), p. 47.

and remaining until the outbreak of the Franco-Prussian War in 1870. He would resume studies under Bonnat in 1874 and remain an additional six years. Blashfield later recounted: "By the time the formalities necessary for an American to enroll in the Beaux-Arts had been accomplished I determined to remain under Bonnat, from whom I felt I was learning a great deal, and thereafter, went to Gérôme only for occasional criticisms and advice."[48]

Bonnat, in turn, admired Gérôme, recognized his particular sympathy for classical subjects, and counseled his student to seek criticism from him. As Blashfield recalled:

> My master in Paris, M. Bonnat, one day advised me to show to Gérôme a Roman subject just begun, as to a *passé maître* in all things relating to classical antiquity, adding, 'There is no better master anywhere, and il est bien bon garçon' (he is a capital fellow). Gérôme permitted me to bring pictures as often as I wished, and he was almost more than kind in giving time and attention to young men, talking by the half-hour with enthusiasm of classical antiquity, saying, 'Surround yourself with everything that you can,—casts, photographs, terra-cottas, vase paintings,—and look at them constantly with all your might.[49]

In an interview of 1927, Blashfield recalled the mutual admiration of his teachers, "the broad-mindedness of these big Frenchmen," each of whom had designated the other as among the best in France. "In view of their technique it was as if Seymour J. Guy and John Sargent were each giving the other the first place. . . . Again and again I was to remark the toleration and even admiration which Masters antipodal in methods sincerely felt and expressed for each other."[50]

Even in the absence of formal affiliation, then, it is possible to predict the influence of Gérôme's stylistic and subject commitments in Blashfield's works. Blashfield himself noted, "probably my admiration for Gérôme led me to try to paint ancient Romans."[51] A number of his Salon contributions of the 1870s reveal Gérôme's influence. These include the gladiatorial image of *The Emperor Commodus [dressed as Hercules] Leaving the Arena at the Head of the Gladiators* (fig. 38), which echoes the arena-floor perspective and compositional arrangements of Bridgman's *Diversion of an Assyrian King* (fig. 33), also shown in the Salon of 1878. Both paintings ultimately derive from Gérôme's well-known

48. Blashfield quoted in interview with DeWitt McClellan Lockman, July 1927, New-York Historical Society, Lockman Papers (Archives of American Art microfilm).

49. Blashfield in "Open Letters," *The Century* 37 (February 1889): 635.

50. Blashfield quoted in interview with Lockman, July 1927.

51. Note by Blashfield on *verso* of reproduction of *Group of Soldiers*, Archives of American Art, Blashfield Papers; quoted in Léonard N. Amico, *The Mural Decorations of Edwin Howland Blashfield (1848–1936)* (exh. cat., Sterling and Francine Clark Art Institute, Williamstown, Massachusetts, 1978), p. 13.

38. Edwin Howland Blashfield, *The Emperor Commodus [dressed as Hercules] Leaving the Arena at the Head of the Gladiators*, Salon 1878. Oil on canvas. 44½ x 91 inches. The Hermitage Foundation, Norfolk, Virginia.

arena scenes, such as his *Ave Caesar* (fig. 5), which Blashfield and Bridgman, like Eakins, would have seen during its successful exhibition at the Exposition Universelle of 1867. Blashfield's work follows Gérôme's theme and processional arrangement of gladiatorial types very closely, combining these elements from *Ave Caesar* with the gesturing crowd and stocky central figure who appear in Gérôme's *Pollice Verso* of 1874 (fig. 31). Blashfield might well have known this painting, upon which Gérôme worked for many years and which had been exhibited once in Paris before being acquired by the New York collector, A. T. Stewart, immediately after its completion.[52] (Stewart's purchase is typical of the rapidity with which Gérôme's works left his studio and entered American collections, either as a result of prior commissions or "on the spot" sales.) Certainly, Blashfield, like other American and European artists and collectors, came to know *Pollice Verso* through Goupil's popular photogravures. One of Gérôme's most famous paintings, *Pollice Verso*, describes on a large scale the victory of a gladiator who looks to the audience for instructions, the Emperor who gauges the mood of the crowd, and the ironic unanimity with which the Vestal Virgins— robed in white to symbolize purity and peace—unmercifully reverse their thumbs to demand the death of the suffering victim.

Contemporary critics noted analogies between Blashfield's Salon painting of 1879, the unlocated *Roman Ladies Taking a Fencing Lesson*, and works by Gérôme. Commenting on this image of more gentle classical genre, the critic for

52. Eric Zafran, "Edwin H. Blashfield: Motifs of the American Renaissance," *Arts Magazine* 54 (November 1979): 149–150, discusses Blashfield's painting with reference to its sources in Gérôme.

The Art Journal observed, "Mr. Blashfield's large picture is in the style of Gérôme's 'Ave Caesar, Morituri te Salutant,' but is not necessarily the worse for that. Its flesh-tints are in a somewhat amateur state, but the same has sometimes been true of some of Gérôme's flesh-tints."[53]

Although the technique of *Roman Ladies* was likened to that of Gérôme, the works that Blashfield painted during his second period of study under Bonnat more often tend to reveal the more "painterly" style of his teacher. However, in the ideal easel and mural paintings that generated his mature reputation, Blashfield frequently discloses Gérôme's stylistic influence in the distilled linear definition of forms, and in the accurate rendering of details of historical costumes and props. The highly elaborated and intellectual allegories that Blashfield invented for these works are also closer to Beaux-Arts principles than to the spirit of Bonnat. An ambitious example is the nine-by-nineteen-foot mural lunette depicting *Manufacture*, or *The City of Pittsburgh Offering Her Iron and Steel to the Commerce, Industry, Navigation and Agriculture of the World*, which Blashfield completed in 1895 for the main hall of the Bank of Pittsburgh (fig. 39).

Many of Gérôme's American pupils manifest an intellectual and theoretical engagement with art that exceeds their conveying messages in their paintings. With the exception of Eakins, all of the artists examined thus far were writers as well as painters. Their aims in writing were usually didactic and their expressed taste conservative. In a career of less than twenty years, Shinn produced a number of ambitious studies on international art and American taste, aside from his commentaries on Gérôme. Bridgman shared his experiences of travel in North Africa in print as well as in paint, publishing *Winters in Algeria* in 1890. He also recorded his antipathy for modernist tendencies in contemporary painting in *L'Anarchie dans l'Art*, published in 1898. Weeks produced travel accounts, contributing a series of articles to *Harper's Magazine* which were collected as *From the Black Sea through Persia and India*, published in 1896, and wrote a number of other books and magazine pieces. A highly reputed muralist, Blashfield prepared a collection of his lectures on the theory and practice of decoration for publication as *Mural Painting in America* in 1913. The modernist works that appeared in the Armory Show of 1913 provoked his appeal and rationale for continued commitment to traditional artistic standards, which appeared in *The Century* in April 1914.

The contributions of Kenyon Cox (1859–1919) to American art commentary and criticism were among the most extensive, the product of his twenty-five years as a writer on artistic subjects for *The Nation*, *Scribner's Magazine*, and other journals. His lectures and essays were gathered into six volumes, published between 1905 and 1917. These writings, like those of Bridgman and Blashfield,

53. *The Art Journal* 5 (1879): 32.

39. Edwin Howland Blashfield, *The City of Pittsburgh Offering Her Iron and Steel to the Commerce, Industry, Navigation and Agriculture of the World*, 1895. Oil on canvas. 9 x 19 feet. Installed as a mural, main hall, The Bank of Pittsburgh; demolished, with the building, May 1944. Photo: Pauline King, *American Mural Painting* (New York, 1902), p. 253.

assert the authority of tradition in the face of burgeoning modernism. The visual paradigm of Cox's beliefs is his painting of 1916 (fig. 40), which shows the allegorical title figure, *Tradition*, conveying light from the torch of the seated representative of the art of the past to latter-day embodiments of classical literature and painting, dressed in Renaissance costume.

After a period of study from 1870 to 1874 at the McMicken School of Design (later the Art Academy of Cincinnati), Cox enrolled in the Pennsylvania Academy of the Fine Arts in 1876, where the French-trained Schussele and Eakins were both teaching. Study there should have predisposed Cox to orthodox academic study abroad. However, in 1877, he entered the independent Parisian atelier of Carolus-Duran (1838–1917), Sargent's teacher, whose style was based on seventeenth-century Spanish painterliness even more fully than was that of Bonnat. Records of the Ecole des Beaux-Arts reveal that in April 1878, Cox was inscribed among the pupils in the atelier of Cabanel, who is rarely mentioned in connection with Cox, not even by the American artist himself. Upon his matriculation in the Ecole in August 1878, Cox was still listed as a student of Cabanel. But he transferred to Gérôme's atelier in February 1879, and thereafter referred to himself as a pupil of Gérôme (and occasionally, of Carolus-Duran).

In a rare reminiscence of Gérôme, Cox provides an image of his flexibility and sympathy for individual students' traits. Like his fluid approach to subject, Gérôme's liberality accords with the fact of his appeal to a broad variety of students. Cox wrote:

> I think there is a general impression that he is very rigid in his methods of instruction and that his pupils become, almost of necessity, his imitators. As a pupil of his during three years, and one who owes him much, I feel that

40. Kenyon Cox, *Tradition*, 1916. Oil on canvas. Signed and dated. 41¾ x 65¼ inches. The Cleveland Museum of Art. Gift of J. D. Cox.

this impression should be corrected. During all the time I was working in l'Ecole des Beaux Arts under his instruction I saw but two pupils whose work showed any decided imitation of Gérôme's own methods of painting, and I never saw any attempt on the part of the master to change the methods of his other pupils. Gérôme has a method of setting his palette which differs somewhat from that employed by most artists; a method which could, I think, only be employed by an artist exclusively devoted to form and comparatively indifferent to quality of color. When I began to paint for the first time under his instruction he recommended this method to me. I had already acquired other methods and did not change them, and he never again recurred to the matter. His criticism was always of results, and never, after that first time, of methods.[54]

Cox's description of Gérôme's broad-mindedness as a teacher is matched by the recollections of Will Hicok Low (1853–1932), another successful American mural painter and art critic. Low reversed Cox's course of study in Paris, transferring from Gérôme's atelier to that of Carolus-Duran. However, Low was never formally inscribed among Gérôme's pupils at the Ecole des Beaux-Arts. His unpublished autobiography notes that, with a letter of introduction from Gérôme's friend, the American Consul-General, and accompanied by Weir and Wyatt Eaton, who were already working under Gérôme, he presented himself for ad-

54. Cox in "Open Letters," *The Century* 37 (February 1889): 635.

mission to the atelier in the spring of 1873. Writing in the third person, Low recalled:

> His heart beating with emotion, he followed his two guides as they entered the studio where the Master, having finished his morning's task of criticism and correction, was drawing on his gloves before making his departure. Two of the more advanced pupils stood beside him holding, one, his hat, the other his cane. Behind him the whole number of the class, fifty or sixty strong, had risen and stood respectfully. The whole scene was formal and to the young barbarian habituated to the free and easy manner of his own country, unspeakably impressive.
>
> His two companions explained the purpose of their presence, produced Mr. [Meredith] Read's letters, then waited as Gérôme read, first scrutinizing the young candidate with a somewhat doubtful expression which softened as he came to his friend's note. "The studio is already too crowded. I had decided not to admit any more pupils for the present," he remarked, "but I could not refuse a friend and you may tell your comrade that if he can find a place to crowd in, I will allow it."[55]

Recalling the studio routine in a published reminiscence, Low noted:

> On Tuesdays and Fridays a hush of anticipation could be felt in the noisy studio, and about nine, a whisper of '*Le patron*' gave the signal, passed from one to another in studio slang, that the master had come. Until his departure not a sound disturbed the measured cadence of his voice as, with few well chosen words, he went his round of criticism. Once in a while he would take the stick of charcoal from the student, and, with a line, which seemed as absolute as the written law, correct the drawing, and occasionally his long thumb-nail would serve a like purpose, making an incised line down the contour of the figure drawn, accompanied by a word—'*Comme ça*'—of comment. I think that I never saw him paint on any of the studies in color, but his criticisms of these were of great liberality of view, so much that leaving his instruction after a few months on account of ill-health, and entering the newly formed *atelier* of Carolus-Duran, there was no susceptible change of criticism.[56]

Low's "ill health" was exacerbated by the environment of Gérôme's atelier, which he described elsewhere:

55. Will H. Low, *The Primrose Way*, typescript, "revised and edited from the original MS by Mary Fairchild Low, with the collaboration of Berthe Helene MacMonnies," 1935 (Albany Institute of History and Art).

56. Low, "Jean-Léon Gérôme," in Van Dyke, ed., *Modern French Masters*, p. 39. See also Low in "Open Letters," *The Century* 37 (February 1889): 635, and Hering, *Gérôme*, p. 201.

I found about seventy students crowded into a room that was scarcely large enough for half the number, heated in a primitive fashion, by a circular iron stove in which wood was burned, and with windows hermetically closed at all seasons . . . the foul air and the difficulty of working in such a compact of humanity finally drove me to another atelier and another master.[57]

Other factors undoubtedly played a part in turning Low from orthodox academic instruction. He was especially frustrated with extensive drawing from casts and from life, unavoidable obligations in Gérôme's atelier, and was anxious to begin working in color. "The maxim of Ingres that 'drawing is the probity of art' was served to us as our daily fare," he remarked later.[58] In Barbizon in the fall of 1873, Low met Jean-François Millet, who counseled him against abandoning academic training in favor of work in the countryside. Returning to Paris, Low briefly resumed work in Gérôme's atelier, but then transferred to the independent studio of Carolus-Duran. This successful portraitist, whose instructional emphasis was upon direct painting, would have alleviated Low's frustration with constant drawing, and would have seemed an agreeable compromise between the attractions of freedom at Barbizon and the need for some sort of formal study. Low's Salon contribution of 1876, *Reverie in the Time of the First Empire*,[59] reflects his dual training, combining Gérôme's emphasis on careful compositional construction with the painterly surface preferred by Carolus-Duran. Reminiscences of Gérôme's interests are even more obvious in Low's later works, especially in the genteel neoclassical mood of his easel paintings, such as *Love Disarmed* (1889; fig. 41), his book and magazine illustrations, and his murals.

Wyatt Eaton (1849–1896), who had joined Low in visits to and in profound admiration of Millet, had significantly more contact with Gérôme than did his friend. He had entered his atelier at the Ecole in October 1872 for a period of four years, having worked for five years under Joseph Oriel Eaton (1829–1875) and at the National Academy of Design, New York. Despite his lengthy affiliation with Gérôme, Eaton's artistic dependence upon Millet, evident in *The Harvest Field* (1884; fig. 42), and his personal advocacy of the Barbizon master far exceeded that which he manifested in relation to his teacher at the Beaux-Arts. As Low noted, "My unquestioning admiration for the man [Millet] and his work appeared to Eaton lukewarm in comparison with his own and, in the disputatious arguments that sweeten the lives of sworn friends when they are artists and young, he scorned me as severely as though I were one of little faith."[60]

57. Low, *A Painter's Progress* (New York, 1910), pp. 164–165.
58. Low, *A Painter's Progress*, p. 158.
59. The painting, recorded in the Thacher Collection, Albany, New York, is illustrated in Low, *A Chronicle of Friendships, 1873–1900* (New York, 1908), opp. p. 170.
60. Low, *A Chronicle of Friendships*, pp. 111–112.

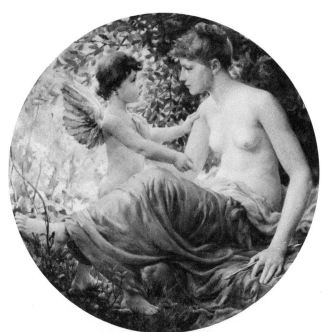

41. Will Hicok Low, *Love Disarmed*, 1889. Oil on circular plywood panel. Signed and dated. 36⅛ x 36⅛ inches. The Brooklyn Museum: Dick S. Ramsay Fund, Augustus Graham School of Design Fund, Caroline A. L. Pratt Fund, and Charles Stewart Smith Memorial Fund.

42. Wyatt Eaton, *The Harvest Field*, 1884. Oil on canvas. Signed and dated. 35½ x 46⅛ inches. The Montreal Museum of Fine Arts, gift of Mr. R. B. Angus.

43. Wyatt Eaton, *Ariadne*, 1888. Oil on canvas. 14⅛ x 18½ inches. National Museum of American Art, Smithsonian Institution, Washington, D.C., Gift of William T. Evans.

However, Low recorded that Eaton had "a hearty respect for Gérôme, agreeing with me that, as a master, as his record had already shown, he was capable of forming pupils whose qualities differed greatly from his own."[61] Eaton, himself, offered informative, if brief, remarks on Gérôme's instructional approach that echo his compatriot's comments, just as many of his late works, including *Ariadne* (1888; fig. 43), resonate with the "neo-Grec" spirit of Low, and, ultimately, of Gérôme. Eaton observed:

> I found him large and catholic in his instruction, as direct and exact in his criticism as the click to the lock of a gun. Oblivious to methods, seeking to develop each pupil's peculiarities and temperament, he frowned upon any attempt to follow in his ways unless he thought it entirely within the sympathies of the pupil. He insisted upon absolute portraiture in the drawing of the figure, and was quick to notice any deviation from the general color or complexion of the model as in the form.[62]

61. Low, *A Chronicle of Friendships*, pp. 113–114.
62. Eaton in "Open Letters," *The Century* 37 (February 1889): 635–636.

Accommodating Academic Ideals to American Imagery

ASIDE FROM REMARKING on his commitment to truth to nature and on his liberality as a teacher, Gérôme's American pupils frequently mentioned his shortcomings as a colorist. They recalled that he was attentive to observation and recording of color, but they noted that he restrained its role in executing his works, as he did the expressive potential of paint and brushwork. So, for example, Cox commented: "Gérôme is, in my idea, a master of line and of composition, but a poor painter"[63] Acknowledging Gérôme's deficiencies as a colorist, and yet defending him as an artist, Blashfield noted: "Gérôme was the smoothest of painters, his color was less than negligible, nevertheless he was not negligible, he was Gérôme for all that."[64]

Among his American pupils, George deForest Brush (1855–1941), who entered his atelier in October 1873, offered one of the most extensive defenses of Gérôme's coloristic commitments. However he, too, remarked on their shortcomings:

> I believe Gérôme's strength lies in portraying the grand, the dramatic, and the strongly individual; in perfection of drawing and complete harmony and unity of design. I know of no modern master who has covered such a wide range of feeling, and of none who has brought the art of composition to such perfection; and although his sense of color is the least delicate of his qualities, yet it is remarkable how frequently he produces a canvas fine in this respect. . . . His method of painting is simple, and good men who have followed it sincerely have become the best colorists—such as [P.A.J.] Dagnan-Bouveret, [Charles] Bargue, and Abbott H. Thayer. His strong love of character is, I believe, the key to his choice of subjects, which are most frequently of semi-barbaric people, in whom individuality is more strongly pronounced than among the civilized.[65]

Brush's predisposition to Gérôme is explained in large measure by the fact that he had studied for two years at the National Academy of Design, New York,

63. Cox in "Open Letters," *The Century* 37 (February 1889): 634.
64. New-York Historical Society, Blashfield Papers, quoted in Zafran, "Blashfield," *Arts Magazine* 54 (November 1979): 151.
65. Brush in "Open Letters," *The Century* 37 (February 1889): 634–635.

44. George deForest Brush, *Before the Battle*, 1884. Oil on canvas. Whereabouts unknown. Photo: George William Sheldon, *Recent Ideals of American Art* (New York, 1888), opp. p. 114, courtesy of Joan B. Morgan.

before enrolling in Gérôme's atelier in October 1873. His teacher at the Academy, Lemuel Everett Wilmarth (1835–1918), had been Gérôme's first American pupil, and undoubtedly instigated Brush's interest in pursuing a similar course, as he would also do for Thayer, Weir, Bunker, and numerous others. Brush's early paintings, done after his return to the United States in 1880, clearly reflect his assimilation of the characteristics and approaches that he admired in his master's work.

Brush found his own "semi-barbaric" subjects in American Indian tribes, with whom he lived in the early 1880s, and in Canadian tribes, whom he observed between 1886 and 1888. They offered him raw material analogous to the North African types whom Gérôme had studied in their exoticism and their potential for dramatic compositions. As Gérôme had done, Brush sketched extensively during his travels, and collected artifacts and, possibly, photographs, for later reference. He also seems to have hired Indian models for additional studies made in New York. Thus, his earliest Indian images are characterized by carefully investigated anatomical forms and ethnographically correct costumes and props. They are also executed in the rather dry and hard manner of his teacher. Typical is *Before the Battle* (1884; fig. 44), in which a tribal ritual of the Plains Indians is meticulously delineated with scrupulous attention to detail. The lucid staging of the dialogue between the group of young Indian warriors and an elder of their tribe specifically recalls the confrontational arrangement of Baron Antoine-Jean Gros' account of *The Capitulation of Madrid, December 4th 1808* (Salon 1808; Musée du Château, Versailles).

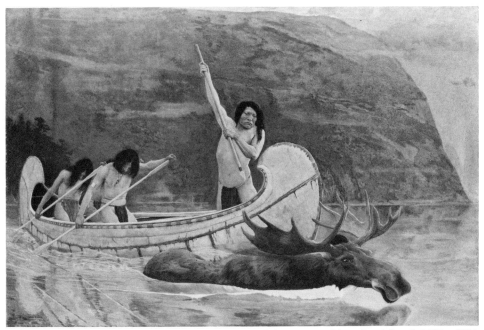

45. George deForest Brush, *The Moose Chase*, 1888. Oil on canvas. Signed and dated. 37⅝ x 57⅜ inches. National Museum of American Art, Smithsonian Institution, Washington, D.C., Gift of William T. Evans.

As one scholar has recently noted, Brush tended to compromise strict historical accuracy in the later 1880s, adapting a more "romanticized" view of the Indian for more eloquent compositions.[66] *The Moose Chase* (1888; fig. 45) is a case in point, presenting a dramatic image centered on the quintessentially powerful and bold Indian hunter. The detailed anatomy of the central figure, his vigorous gesture and those of his companions recall elements of Gérôme's *The Prisoner* (fig. 26), which had appeared in Shinn's monograph of 1881–1883, while adapting them to the thematic resources of North America. In the late 1880s, Brush increasingly departed from such contemporary Indian scenes to investigate historical ethnography. His several depictions of Pre-Columbian artists at work, such as *The Sculptor and the King* (1888; fig. 46), translate the French tradition of historical studio portrayals into the American mode, much as Eakins had done in his *William Rush* series. The fluidity of Brush's approach to subject matter—his ability to move freely from contemporary to historical genre—recalls that of his teacher and of his compatriot, Frederick Bridgman.

In light of this fluidity of subject choice, it is not surprising that Brush also

66. Joan B. Morgan, "The Indian Paintings of George deForest Brush," *American Art Journal* 15 (Spring 1983): 69–70.

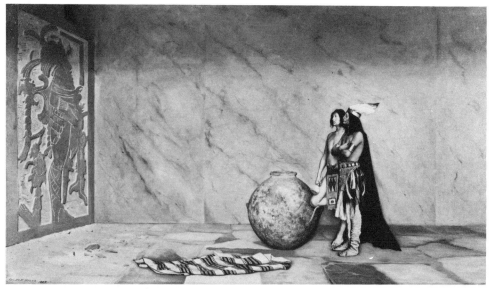

46. George deForest Brush, *The Sculptor and the King*, 1888. Oil on panel. Signed and dated. 20 x 36 inches. The Portland Art Museum, Portland Oregon, Gift of Miss Mary Forbush Failing.

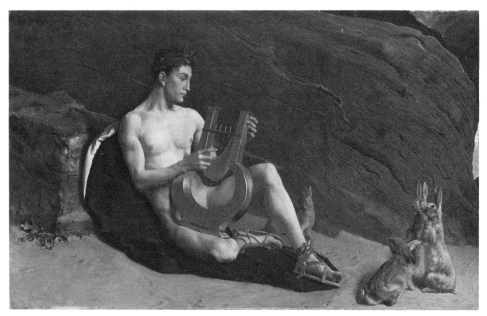

47. George deForest Brush, *Orpheus*, 1890. Oil on panel. Signed and dated. 12 x 20 inches. Jo Ann and Julian Ganz, Jr., Los Angeles.

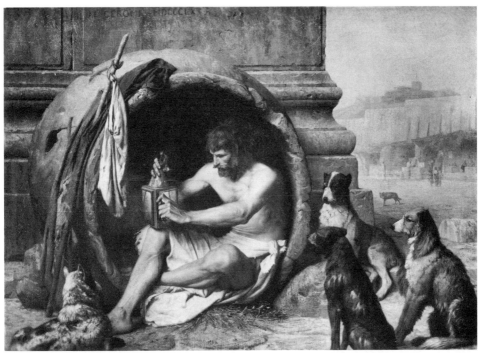

48. Jean-Léon Gérôme, *Diogenes*, 1860. Oil on canvas. Signed and dated. 29⅜ x 39¾ inches. Walters Art Gallery, Baltimore.

explored themes of "genrefied" classical history. His *Orpheus* (1890; fig. 47) is strikingly reminiscent of Gérôme's *Diogenes* (1860; fig. 48), which was in a New York collection by 1873 and was reproduced in Shinn's monograph. In Gérôme's painting, the Greek cynic philosopher is shown in his barrel home in the Athenian Stoa, lighting the lantern for his search for the honest man. As he is said to have "lived like a dog," they join him as attributes. Their counterparts in Brush's painting are the rabbits whose attention to Orpheus's music attests to his legendary ability to charm the beasts. The paintings are similar not only in their compositions, in their lucid rendering of male anatomies and other details, in their juxtapositions of classical characters with animals, but in their description of gentle and "human," rather than dramatic moments in the classical past.

Many of Brush's later paintings, typified by *Mother and Child* (1895; fig. 49), cast members of his family (including his son, Gérôme Brush, born in 1888) into secular "madonna and child" guises. These paintings are related to Old Master, specifically Renaissance sources, to which Gérôme had commended his pupils' attention. They also recall the religious images of Gérôme's teacher, Delaroche (see fig. 50), which often combined traditional iconography with characteristically nineteenth-century physiognomic types.

49. George deForest Brush, *Mother and Child*, 1895. Oil on circular panel. 38½ x 38½ inches. Courtesy Museum of Fine Arts, Boston, William Wilkins Warren Fund.

Although his Indian paintings were critically acclaimed and won him patronage during the 1880s, Brush concentrated on such family images in the Old Master mode in later decades. His disillusionment with governmental treatment of the Indian has been posited as a cause for his abandoning Indian themes.[67] Another likely explanation is his desire for increased patronage from collectors who were acquiring Old Master paintings and who might have been sympathetic to American works that were resonant in spirit and appearance. The ubiquitous interest in the "ideal woman" among turn-of-the-century American artists and intellectuals would also have affected Brush and increased the popularity of these works.

In his reminiscences of Gérôme, Brush reiterated the impression of his flexibility in accepting various technical approaches and his absolute devotion to truthful recording of nature upon which other American students had remarked:

> As a teacher he is very dignified and apparently cold, but really most kind and soft-hearted, giving his foreign pupils every attention. In his teaching he avoids anything like recipes for painting; he constantly points out truths of nature and teaches that art can be attained only through increased perception and not by processes. But he pleads constantly with his pupils to understand that although absolute fidelity to nature must be ever in mind,

67. Morgan, "Indian Paintings," *American Art Journal* 15 (Spring 1983): 62–63.

50. Hippolyte (Paul) Delaroche, *Virgin and Child*, 1844. Oil on canvas. Signed and dated. 58½ x 35¼ inches. Reproduced by permission of the Trustees, The Wallace Collection, London.

yet if they do not at least make imitation serve expression they will end as they began—only children.[68]

Commenting upon Brush, and upon Thayer, in relation to their training under Gérôme, Charles H. Caffin observed in 1907 that these artists had amply measured up to their teacher's instructional attitudes and his hopes for his pupils: "What we may believe they derived from him was a mental discipline and faculty of thought which enabled them to put to entirely independent uses the principles that they learned from him, and ultimately to give free rein to their own imagination."[69]

Douglas Volk's (1856–1935) period of study in Gérôme's atelier followed some instruction in Rome and coincided generally with that of Brush, who became his lifelong friend. Returning to the United States in 1879, he also effected a transformation of Gérôme's exotic genre similar to that which informs Brush's early works. Volk devoted himself principally to images of American colonial life, especially scenes from seventeenth-century Puritan society. *The Puritan Maiden* (NAD 1881; fig. 51) is as chaste a domestication of Gérôme's exotic *almehs* as might be imagined. Here, Volk records the costume and describes the sentiments of a young woman who has bidden farewell to her lover, whose retreating footprints appear in the snow. In another meditative historical costume piece, *Ye Maiden's Reverie* (1898; fig. 52), Volk invokes both Gérôme's interest in historical genre and the spirit of his graceful female portraits (see fig. 14).

Volk developed a wide reputation as a portraitist himself, and was active as a muralist. He was also a highly committed teacher of art and lecturer and writer on art instruction. His own pedagogic aspirations reflected his fruitful relationship with Gérôme, whose effect on his students Volk recalled in 1904:

> I doubt if any master of our times was held in greater reverence by his pupils than Gérôme. In fact, this feeling amounted almost to an overwhelming awe when the man entered the government studio in the Ecole des Beaux-Arts on the occasions of his bi-weekly criticisms. A state of pandemonium often reigned supreme among the forest of easels that choked this historical place. . . . But when, at the appointed time, the great door of the studio opened softly and Gérôme entered what a sudden stillness fell on that crowd of restless workers. Then did all wait reverently on his every word.[70]

While Volk's commitment to Puritan genre parallels Brush's early interest in

68. Brush in "Open Letters," *The Century* 37 (February 1889): 634–635. See also Hering, *Gérôme*, p. 202.

69. Caffin, *The Story of American Painting* (New York, 1907), p. 177.

70. Volk in "The Genius of J. L. Gérôme," *New York Herald Magazine* (31 January 1904): 8.

51. Douglas Volk, *The Puritan Maiden*, NAD 1881. Oil on canvas. Signed. 30 x 24 inches. Whereabouts unknown. Photo: *Scribner's Monthly* 22 (July 1881): 328.

52. Douglas Volk, *Ye Maiden's Reverie*, 1898. Oil on canvas. Signed.
45 x 28 inches. The Berkshire Museum, Pittsfield, Massachusetts, Gift
of Zenas Crane.

American Indian imagery, Abbott Handerson Thayer's mystically idealized contemporary females, such as his *Virgin Enthroned* (1891; fig. 53), are consistent in spirit with Brush's later works. Thayer (1849–1921) had devoted himself to animal subjects during his earliest artistic training, which he undertook in Boston in 1863 under the amateur animal painter, Henry Dutton Morse (1826–1888). After a year of study at the Brooklyn Art School and four years at the National Academy of Design, New York—during which he developed sufficient skill to have his animal paintings accepted at the NAD's annual exhibitions—Thayer decided to seek additional training in his specialty in Paris. Although he had worked with Wilmarth in New York, Thayer did not immediately seek admission to Gérôme's atelier. Originally he planned to work with an animal painter, such as Auguste Bonheur (1824–1884), but he enrolled instead in the atelier of Henri Lehmann (1819–1882). This history painter and muralist had succeeded Pils as a *chef d'atelier* in the Ecole des Beaux-Arts just ten days before Thayer's inscription in October 1875.

However, one of the earliest paintings preserved from Thayer's period of Parisian study suggests that his sympathies lay more with the exotic genre subjcts of Gérôme than with the serious and allegorical works of Lehmann. His *At the Marketplace, Paris* (1875; fig. 54) recalls Gerome's images of exotic courtyards and marketplaces, such as *The Pifferari* and the somewhat later *Saddle Bazaar* (figs. 10 and 35). Although Thayer's account of the curiosities of French types is signed and dated—and is, thus, completed—it retains the quality of a compositional sketch, rather than a "finished" work. It thereby anticipates the persistence of a painterly style in Thayer's work despite his extensive academic training.

Thayer remained in Lehmann's studio until March 1876, when he was admitted to matriculation in the Ecole proper. One month later, he transferred to Gérôme's atelier. Here, he joined the friendly pair of Brush and Volk, who had been working with Gérôme for two-and-one-half years, and later remained close with them as they all pursued careers in New York. Gérôme was not unsympathetic to animal imagery, which formed, in fact, an important element in his work, providing subjects for entire paintings or serving as major motifs in classical or exotic genre scenes (see figs. 13 and 35). Yet Thayer's three years of study with him confirmed the shift of his interests from animal to human subjects. In requisite *académies* executed in Gérôme's atelier, such as his *Female Nude* (c. 1876; fig. 55), Thayer continued to reveal an unusual freedom in the handling of paint. This reflects the fact that these weekly exercises were not expected to be highly finished. They were usually scraped down and repainted later, if a "painting" or "composition," rather than a study were the goal. However, these works also verify the liberality of Gérôme's criticism, which seems to have accommodated Thayer's generally loose and sketchlike style. The American's most recent biographer has noted: ". . . Gérôme did not insist upon exact

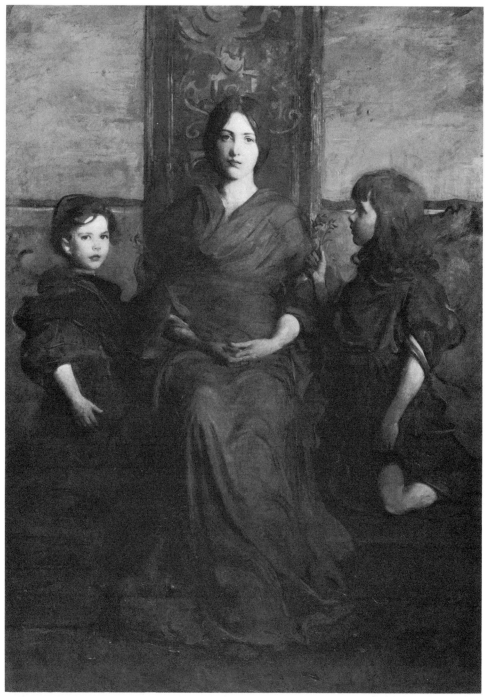

53. Abbott Handerson Thayer, *Virgin Enthroned*, 1891. Oil on canvas. Signed. 72½ x 52½ inches. National Museum of American Art, Smithsonian Institution, Washington, D.C., Gift of John Gellatly.

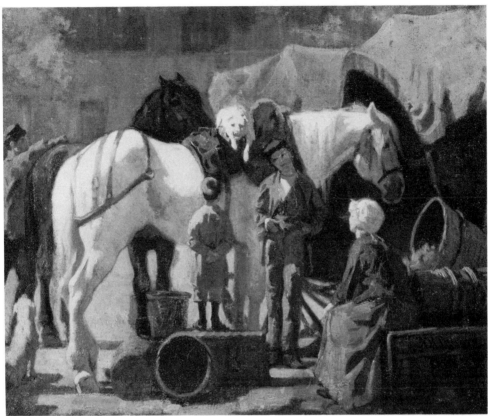

54. Abbott Handerson Thayer, *At the Marketplace, Paris*, 1875. Oil on canvas. Signed and dated. 16 x 21 inches. Lyman Allyn Museum, New London, Connecticut.

replication of his techniques among his students. In fact, his studio was unofficially divided into two groups: one painted in a manner similar to that of the master; the other, to which Thayer belonged, was more impressionistic."[71]

In later years, Thayer vividly recalled to a younger painter his affection for academic training and his concurrent concern with loss of originality:

> I myself believe that systematized art training is generally unsuccessful. It is somehow in the same relation to art the "schools" in the sense of followings, are to each master—"the Rembrandt School," "the Titian School" . . . etc., always the systematization of the master's excesses. . . . But it is doubtless good to give system a trial. . . . If you are a genius your own Daemon begrudges your devotion to formulated systems and mutters inside you that

71. Ross Anderson, *Abbott Handerson Thayer* (exh. cat., Everson Museum, Syracuse, 1982), p. 15.

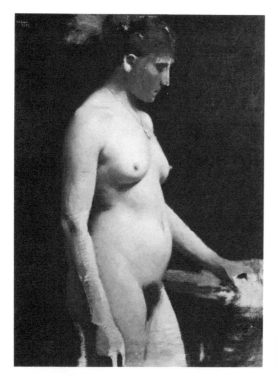

55. Abbott Handerson Thayer, *Female Nude*, c. 1876. Oil on canvas. 26 x 35 inches. Nelson Holbrook White, Waterford, Connecticut.

he has his own special needs which he is ready to make known to you if you will only keep quiet and not drag him against his mutterings into the factory jangle of an art school where you can't hear his whispers. . . . Practically this means if you *love* the school it is a sign your Daemon does. It was so with me, I *loved* Gérôme's atelier. It was like riding wild horses, those week long model paintings.[72]

With their simplified forms and scumbled surfaces, Thayer's mature works, such as his *Half Draped Figure* (1885; fig. 56), expand the "painterly" tendencies that characterize his "week long model paintings." Despite his deviation from Gérôme's style, Thayer reveals the durable influence of Gérôme's principles in his frequent references to those "week long model paintings" as compositional armatures, his devotion to monumental, sculpturesque forms, his frequent use of classical draperies, and his reliance upon photographs for study purposes. The allusions to Old Master sources that appear in Thayer's works—as they do in those of Brush—also recall the emphasis that Gérôme and other Beaux-Arts painters placed upon close examination and creative recycling of the art of the past. Thayer himself noted in a letter of 1918: "In the École des Beaux-Arts I

72. Thayer to William James [the painter son of the psychologist], 18 November 1904, Archives of American Art, Thayer Papers, quoted in White, *Thayer*, p. 25.

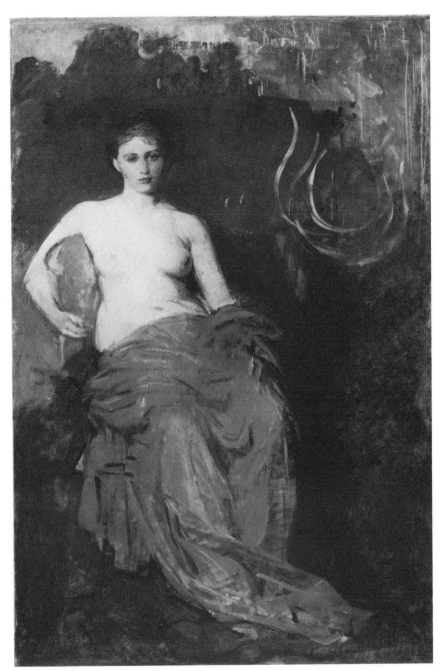

56. Abbott Handerson Thayer, *Half Draped Figure*, 1885. Oil on canvas.
71⅜ x 47¾ inches. National Museum of American Art, Smithsonian Institution,
Washington, D.C., Gift of John Gellatly.

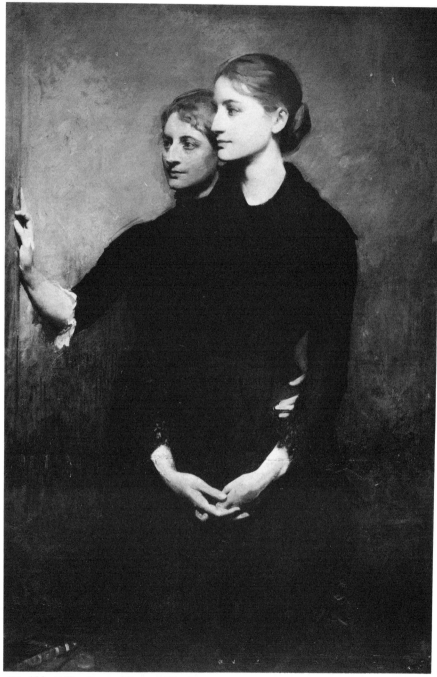

57. Abbott Handerson Thayer, *The Sisters*, 1884. Oil on canvas. 54¼ x 36⅛ inches. Courtesy of the Brooklyn Museum, Bequest of Bessie G. Stillman.

was principally with Gérôme who admirably held up to us all the examples of the masters of the Renaissance and those have continued to be my luminaries."[73] Thayer's portraits, such as *The Sisters* (1884; fig. 57), are often based on photographs, and reiterate the grace and even the poses of those of Gérôme (see fig. 14).

Although animal imagery receded in importance in Thayer's oeuvre during the 1880s and '90s, he maintained his early interest in animals and natural history. In his scientific renderings of birds and animals in their own habitats, particularly of their protective coloration or camouflage, Thayer used a photographic technique that depends ultimately upon the investigative principles of Gérôme. Thayer, himself, remarked on Gérôme's commitment to the scrupulous transcription of nature, noting:

> The thought of Gérôme arouses first of all, in an artist's heart, the sentiment of truth-worship. Whatever the degree of his appetite for his paintings, they must forever magnetize each fellow-artist by their stamp of a great nature's austere fidelity, and their purity in those respects which were plainly his aim destines them to last among a very few to represent his epoch hereafter. . . .
>
> One of my innermost longings will always be to get his approval of my work.[74]

Undoubtedly, Thayer's late studies, such as *Peacock in the Woods* (1907; fig. 58), would have evoked such approval.

73. Thayer to Helen St. Beatty, 1918, Archives of American Art, Thayer Papers.

74. Thayer in "Open Letters," *The Century* 37 (February 1889): 636. See also Hering, *Gérôme*, p. 201.

58. Abbott Handerson Thayer (and Richard Meryman), *Peacock in the Woods* (study for *Concealing Coloration in the Animal Kingdom*, 1907), 1907. Oil on canvas. Signed and dated. 45¼ x 36⅜ inches. National Museum of American Art, Smithsonian Institution, Washington, D.C., Gift of the Heirs of Abbott H. Thayer.

The Academic Armature of American Impressionism

GÉRÔME'S DEVOTION TO NATURAL OBSERVATION was theoretically consistent with that of such leaders of late nineteenth-century modernism as the Impressionists. However, his objective literalism was procedurally at odds with their commitments and produced visually antithetical results. Nonetheless, several of Gérôme's American pupils turned to Impressionism to enliven their works. As they added this perceptual mode to a fundamentally conceptual one, it is not surprising that their allegiance to Impressionism was both cautious and intermittent. Some merely dressed carefully studied forms in a veneer of impressionistic coloration and brushwork. Others limited Impressionist experimentation to outdoor subjects, while they concurrently produced portraits and other indoor images in the more traditional academic manner.

Julian Alden Weir (1852–1919) was among the American artists who were to affiliate themselves to some extent with Impressionism after a period of study with Gérôme. The son of Robert W. Weir (1803–1889), Professor of Drawing at West Point, and the half-brother of John Ferguson Weir (1841–1926), Professor of Fine Arts at Yale, Weir enjoyed unusual family sympathy for his artistic pursuits. His family's association with art prompted him to provide extensive and specific accounts of his experiences in Paris and, more unusual and fortunate, prompted his correspondents to preserve his letters. Many of these were published by his daughter in 1960; additional letters are quoted in a major recent study of the artist.[75] Thus, Weir is an excellent and accessible source of information about Parisian art study during his period abroad, and especially about the practices of his mentor, Gérôme.

Arriving in Paris in the fall of 1873, after two years at the National Academy of Design, New York, Weir wrote to his mother: "The first thing I shall do now is to go about and look at the different masters and see what kind of students they have, and get with the one that I think I can learn most with."[76] As Lemuel Wilmarth had been Weir's professor in New York, it is not surprising that he settled upon Gérôme and was inscribed in his atelier on 21 October.

Two weeks later, Julian remarked on his enthusiasm for Parisian training in

75. Young, *Weir*, and Burke, *Weir*. See note 24, above.
76. Quoted in Burke, *Weir*, p. 49.

a letter to his brother, who had encouraged his seeking French training. "You were right in starting me off here," Julian wrote,

> and I never can thank you enough for it. Now if I can study here long enough there may be hope, but I am convinced if I had remained in America until I was older my whole life would have been full of regrets concerning my art, for I know I never should have appreciated what it is to draw well, and what art was without it. After going through a good deal of "red tape," I succeeded in getting admitted to Gérôme's atelier and since then I have been there working from the antique. I began with simple things first and have at times been encouraged by Gérôme by his saying "pas mal" and the last drawing was "mieux."

Having devoted himself exclusively to study from casts, Julian noted that he was about to begin drawing from the living model in the mornings, from eight until half past twelve, and then spend the rest of the afternoon, until four, drawing from the antique (see fig. 16).[77]

In January 1874, Julian again thanked John for recommending French academic training and reiterated the details of his first months under Gérôme:

> I feel that my coming over here has been the most fortunate thing that could possibly have happened to me. My eyes have been opened to see many things that otherwise I know I would not have discovered for years had I continued in the manner I studied when at home. Now my manner of work is entirely different as you will see. After being here a short time I entered Gérôme's atelier where I began at the casts, drawing the heads in and merely blocking out the principal shade, for he considers that that is the first thing for a student to understand thoroughly. After drawing for a month I passed a concours which they have every two months, and entered the life. I worked here another month, making slow progress naturally, but still encouraged by Gérôme.[78]

Ultimately, Weir passed from drawing from life (see fig. 19) to painting from life, producing such *académies* as his *Study of a Male Nude Leaning on a Staff* (fig. 22). His devotion to these exercises, and his belief in their efficacy for art training, prompted him to forward this painted *académie*, together with five similar studies by French classmates (see figs. 20 and 21), to John Weir for use in art instruction at Yale.

The numerous letters that Weir sent to his family during four years of study and travel in Europe are filled with fascinating vignettes of the pleasures and travails of student life, with observations on the contemporary art world, and

77. Weir to John Ferguson Weir, 2 November 1873, quoted in Young, *Weir*, p. 25.
78. Weir to John Ferguson Weir, 11 January 1874, quoted in Young, *Weir*, pp. 27–28.

with commentaries on places visited and paintings viewed. Although he had occasionally considered joining some other Parisian atelier—either because Cabanel's students seemed stronger than Gérôme's, or because of his admiration for Carolus-Duran as a portraitist—he remained with Gérôme throughout that four-year period. Gérôme's fundamental principles appear to have affected Weir's works throughout his career. These principles include a commitment to meticulous draughtsmanship; the use of a tonal and restrained palette; a tendency toward highly ordered, classical compositions; a technical procedure involving careful study of individual objects to be included in these compositions, the execution of elaborate preparatory studies, and the use of photographs for reference; and an investigative approach to all natural objects, the human figure in particular.

Weir's adherence to these principles is already evident in works executed during his student years abroad. An example is *At the Water Trough* (1876–77; fig. 59), the only major painting to have resulted from Weir's visit to Spain, undertaken at Gérôme's suggestion during the summer of 1876. The painting is a more successful, sophisticated, and finished counterpart of Eakins's *Street Scene in Seville* or Thayer's *At the Marketplace, Paris* (fig. 54), and like them, is related to Gérôme's exotic courtyard scenes. Here Weir explores peculiarities of place and populace in a Spanish courtyard. Weir's "glimpse" of Spanish life is anything but casual, as he carefully disposes a balanced pyramidal group of graceful peasants on a shallow foreground stage filled with diverting indigenous props. Executed in Weir's Paris studio, the painting depends upon careful notes and sketches made during his travels and upon Latin models hired for additional study.

In the summer before his departure from Paris, Weir wrote to his mother that he had taken a present to Gérôme, "a piece of sculptured marble that I found when I was in Spain. . . . I owe much to Gérôme which I never can repay and, had I the means, would have made him a regal gift, but as he is a man of 'esprit,' he will appreciate it as much as he would one of great value."[79]

Weir reiterated his perception of Gérôme's influence upon his development in a letter to his brother the same week, and added more or less optimistic notes on his hopes for his own future and for the future of American art:

> Gérôme I regret leaving, his influence is great, but I feel that I have not become ripe anought to imbibe enough of the essence. However, we will help to fertilize the art soil of America, but history shows us that no great geniuses have been produced and flourished until the ideas of the country were in a ripe state. . . . Plant the good seed, we are the manure which will

79. Weir to Mother, 18 July 1877, quoted in Young, *Weir*, p. 130.

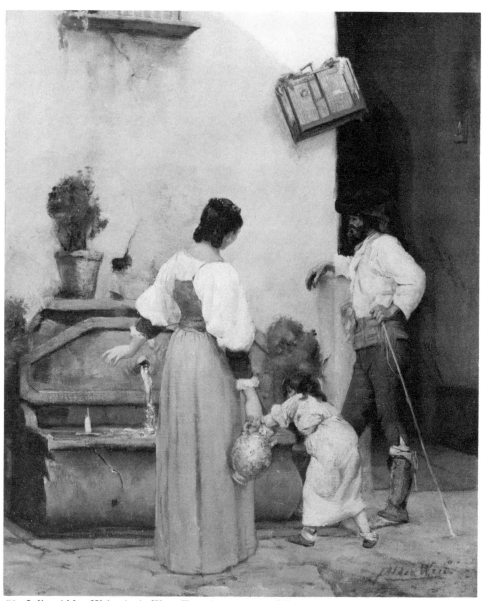

59. Julian Alden Weir, *At the Water Trough*, 1876–77. Oil on canvas. Signed. 17¼ x 14½ inches. National Museum of American Art, Smithsonian Institution, Washington, D.C., Museum Purchase.

do it good, although the 19th Century will not see the effect. I feel that we are, however, going to be a great art nation and hurrah! for America.[80]

For Weir, as for hundreds of other late nineteenth-century American painters, the "good seed" was French academic training.

In light of his faith in Beaux-Arts principles, it is not surprising that Weir was contemptuous of the most radical tendencies visible in French painting during his period of study under Gérôme. Echoing his teacher's caustic attitude, he commented on the 1877 exhibition of

> a new school which call themselves 'Impressionalists.' I never in my life saw more horrible things. . . . They do not observe drawing nor form but give you an impression of what they call nature. It was worse than the Chamber of Horrors. I was there about a quarter of an hour and left with a head ache. . . . I was mad for two or three days, not only having paid the money but for the demoralizing effect it must have on many. . . .[81]

However, he was not unsympathetic to partisans of some newer tendencies, particularly to Jules Bastien-Lepage (1848–1884), the conservative realist, with whom he formed a friendship in Brittany in 1873 which lasted until the French artist's death. Weir also appreciated the works of Edouard Manet (1832–1883), and acquired two of them, together with one by Bastien, as agent for the American collector, Erwin Davis, during summer visits to France in 1880 and 1881.[82] Weir's figure paintings of the 1880s betray a debt to both the more academic and the more modern styles with which he sympathized. The compositional simplicity, expressive contours, and graceful restraint of *Idle Hours* (1888; fig. 60), for example, suggest a domestication of Gérôme's "neo-Grec" genre; its informal subject, creamy brushwork, and flattened space reflect the influence of Manet; and its monochromatic tonalities echo the customary palette of Bastien.

Weir's antipathy to Impressionism subsided almost entirely by the 1890s, when he turned to experimentation with a lighter palette and broken brushstrokes. Like most of the American Impressionists, the majority of whom also experienced academic training and found their sympathy for Impressionism kindled only after the movement had lost its own generative spark, Weir was a cautious and restrained devotee. Like most of his compatriots, he was indebted to the surfaces of Impressionism, rather than to its principles. Like them, he produced works that are more the result of "impressionizing" than of Impres-

80. Weir to John Ferguson Weir, 20 July 1877, quoted in Young, *Weir*, p. 131. See also Hering, *Gérôme*, p. 68, and Weir in "Genius," *New York Herald Magazine* (31 January 1904): 8.

81. Weir to Father and Mother, 15 April 1877, quoted in Young, *Weir*, p. 123.

82. These are Manet's *A Boy with a Sword* (c. 1861), and *Woman with a Parrot* (1866), and Bastien-Lepage's *Joan of Arc* (1879), all of which Davis gave to the Metropolitan Museum of Art, New York, in 1889.

60. Julian Alden Weir, *Idle Hours*, 1888. Oil on canvas. Signed and dated. 51¼ x 71⅛ inches. Metropolitan Museum of Art, New York, Gift of Several Gentlemen.

sionism, and only occasionally and intermittently at that. His impressionist paintings, such as *The Red Bridge* (c. 1895; fig. 61), are consistently chastened by geometric control in compositional arrangements, by linear definition of forms, and by a tonally-based, rather than a purely chromatic palette. Characteristically, too, Weir constructs such an "impressionist" portrait as *The Hunter* (1893; Brigham Young University Art Museum Collection, Provo) on an Old Master armature, most likely Francisco de Goya y Lucientes' portrait of *King Charles III* (1797; Museo del Prado, Madrid) or Goya's ultimate source, Diego Velasquez's portrait of *The Infant Don Balthasar Carlos* (Museo del Prado, Madrid). Concurrently with his Impressionist canvases, Weir painted subjects such as *Face Reflected in a Mirror* (1896; fig. 62) that required no recognition of the effects of outdoor light and atmosphere. Such indoor figure compositions and portraits manifest a reversion to the darker, entirely tonal palette, and to the more linear definition of forms that were fundamental to Weir's early academic training.

A similar stylistic duality appears in the works of Dennis Miller Bunker (1861–1890). Bunker followed instruction under Wilmarth at the National

61. Julian Alden Weir, *The Red Bridge*, c. 1895. Oil on canvas. Signed. 24¼ x 33¼ inches. Metropolitan Museum of Art, New York, Gift of Mrs. John A. Rutherfurd.

Academy of Design and and under William Merritt Chase (1849–1916) at the Art Students League, New York, with enrollment in the Ecole des Beaux-Arts. Already an accomplished draughtsman, he was inscribed in the atelier of Ernest Hébert (1817–1908) in October 1882, eight months after Hébert had succeeded to the position of *chef d'atelier* in Lehmann's place. However, Bunker transferred to Gérôme's studio after only four months. This change was probably not motivated by a desire for a different instructional approach, as Hébert and Gérôme had been colleagues in Delaroche's atelier and remained close friends. Rather, Bunker may have sought the more extensive American comradeship that was available in Gérôme's class, where a dozen-and-a-half Americans had enrolled since 1879. By contrast, American students had avoided Lehmann's studio—none had enrolled after October 1879. Studying under Hébert, Bunker would have had the company of only three compatriots, who also arrived in the fall of 1882.

In one of his few preserved letters home, Bunker wrote sarcastically of both his own and Gérôme's accomplishments. In the spring of 1884, at about the time he also successfully matriculated in the Ecole, he told his close friend, Joe Evans,

62. Julian Alden Weir, *Face Reflected in a Mirror*, 1896. Oil on canvas. Signed and dated. 24¼ x 13⅝ inches. Museum of Art, Rhode Island School of Design, Providence, Jesse H. Metcalf Fund.

that he had finished a portrait of Kenneth R. Cranford (1857-?), a compatriot in Gérôme's studio,

> . . . and think it is the best thing I've painted. The old man said it was leathery but serious, a remark which gave me much to think about. I suppose you have heard that he—the old man—has two things at the Salon— one of them is very beautiful, a moon light night in the desert with some lions playing in the foreground and no end of stars in the sky. Very good stars

63. Dennis Miller Bunker, *On the Banks of the Oise*, 1883. Oil on canvas. Signed and dated.
26 x 36 inches. Berry-Hill Galleries, Inc., New York.

I am hoping to do some sort of little picture this summer, a figure if possible to take back with me, for you know Joe, two winters in the atelier is not generally . . . time of many noble works. In fact it makes me blush to look over the wretched amount of trash that I've made in the past two years. I shall have a grand bonfire here 'ere long.[83]

Bunker did bring home landscapes done during summer sketching trips, which he took with Cranford and Charles Adams Platt (1861–1933), a student at the independent Académie Julian. Such works as *On the Banks of the Oise* (1883; fig. 63) reveal an emulation of Barbizon techniques in their tranquil, intimate compositions and tonal palette. Bunker's Barbizon tendencies were modi-

83. Bunker to Joe Evans, Paris, [spring] 1884, Archives of American Art, Bunker Correspondence. Bunker's portrait of Cranford is reproduced in R. H. Ives Gammell, *Dennis Miller Bunker* (New York, 1953), plate 3. Gerald M. Ackerman to author, 14 October 1983, notes that the painting shown by Gérôme in the Salon of 1884, *La nuit au desert*, now unlocated, was described by a London critic as depicting a "huge tigress" with two of her cubs, rather than the lions that Bunker mentioned.

64. Dennis Miller Bunker, *Wild Asters*, 1889. Oil on canvas. Signed and dated. 25 x 30 inches. Private collection, courtesy of The Vose Galleries of Boston.

fied by his contact with John Singer Sargent in Boston in 1887, two years after his return home. Working with Sargent in the English village of Calcott in the summer of 1888—when Sargent was at the extreme of his interest in experimenting with Impressionist stroke and color—Bunker produced a number of convincingly impressionistic works then and thereafter, including *Wild Asters* (1889; fig. 64). Concurrently, however, he painted portraits such as that of *Jessica* (1890; fig. 65), whose exquisite grace, linear control, and tonal reticence vividly recall his exposure to French academic training under the painter of *Mlle. Durand* (fig. 14).

Although his mature career was tragically curtailed by his death from influenza at age thirty-nine, Bunker's influence was felt by a number of pupils whom he taught at Boston's Cowles Art School. Like Bunker, many of the pupils of Gérôme helped to revise American art instructional practices and to align them in no small measure with those of the Ecole des Beaux-Arts. Under their influ-

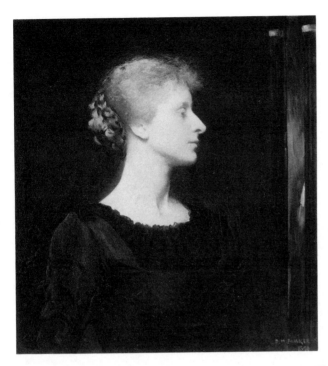

65. Dennis Miller Bunker,
Jessica, 1890. Oil on canvas.
Signed and dated. 26 x 24 inches.
Courtesy, Museum of Fine Arts,
Boston, Gift by Contribution.

ence, the Pennsylvania Academy of the Fine Arts (Eakins), New York's National
Academy of Design (Wilmarth), Art Students League (Cox, Brush, Volk, Weir)
and Cooper Union (Low, Eaton, Brush, Volk, Weir), and other art schools
throughout the United States were transformed according to the French model.

William MacGregor Paxton (1869–1941), who worked with Bunker at the
Cowles School from 1887 to 1889, was one of his most precocious and successful
students. Paxton was in Paris by October 1889, when, at the age of twenty, he
was admitted to work in the Gallery of Antiques of the Ecole des Beaux-Arts,
and to use its library and attend lectures. Concurrently, he studied at the Aca-
démie Julian with Jules-Joseph Lefebvre (1834–1911) and Jean-Joseph
Benjamin-Constant (1845–1902), possibly because a series of illnesses in the
winter of 1889–90 absented Gérôme from the Ecole. Finally, in October 1890,
Paxton followed Bunker's example and, with eight other Americans, enrolled in
Gérôme's atelier. The extensive French academic training that Paxton experi-
enced, both at home and in Paris, was characteristic of American artists of his
generation. Inevitably, it produced a painter who was consistently affected by
academic traditions, whether in his occasional experiments with Impressionism,
or in his more typical indoor vignettes of upper class Bostonians at leisure, such
as *The New Necklace* (1910; fig. 66). Extending the photographic accuracy in
rendering achieved by Gérôme, Paxton depicted volumes and textures in these
works with an uncanny verisimilitude.

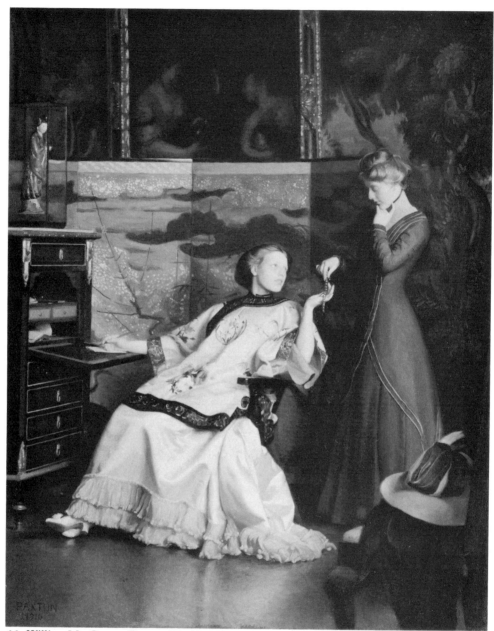

66. William MacGregor Paxton, *The New Necklace*, 1910. Oil on canvas. Signed and dated. 35½ x 28½ inches. Courtesy, Museum of Fine Arts, Boston, Zoe Oliver Sherman Collection.

67. William MacGregor Paxton,
The One in Yellow, 1916. Oil on
canvas, mounted on masonite.
Signed. 56 x 46 inches.
Robert Douglas Hunter, Boston.

Paxton was distinguished not only for his command of illusion, but for his debt to the past for inspiration, particularly to Velasquez, Vermeer, Gainsborough, and Ingres. Of the latter, Paxton recalled, "I spent endless days when I was a kid in Paris in the Louvre copying Ingres drawings. I think Ingres came nearer than any man ever lived in achieving what he set out to do; color did not count and limited range but none nearly his than any one I have seen."[84] Paxton's affiliation with the works of Ingres increased in the later years of his career, yielding such charming curiosities as *The One in Yellow* (1916; fig. 67), which reiterates the figure-reflection relationship of the French master's well-known portrait of the *Comtesse d'Haussonville* (1845; The Frick Collection, New York) in contemporary American dress. His *Two Models* (1931; fig. 68) reduces to a double *académie* Ingres' "composition," the *Odalisque with the Slave* (1839–40; Fogg Art Museum, Cambridge, Massachusetts), which Paxton knew well in a private Boston collection, and which he copied in 1932 (Estate of the Artist).

84. Paxton quoted in interview with DeWitt McClellan Lockman, 4 May 1927, New-York Historical Society, Lockman Papers (Archives of American Art microfilm).

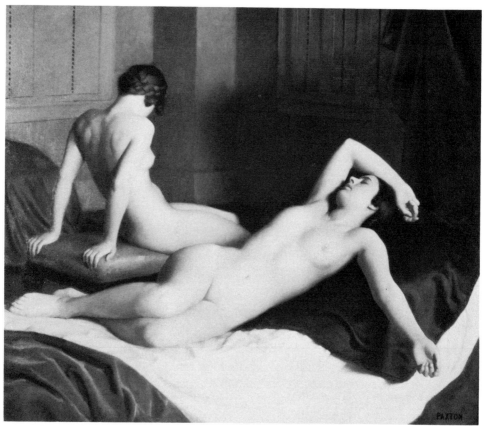

68. William MacGregor Paxton, *Two Models*, 1931. Oil on canvas. Signed. 32 x 38 inches. Courtesy, Joan Michelman, Ltd., New York.

CONCLUSION

The Crisis for Classicism in the Twentieth Century

WHILE PAXTON'S *The One in Yellow* and *Two Models* are technically admirable, they are entirely detached from the moments at which they were painted, hermetically sealed off from the realities of the First World War and the Great Depression. Paxton was not alone among American painters who had immersed themselves in nineteenth-century academic principles in colliding with the actualities of the modern world, and choosing to avoid them by retreating into the world of the studio and of the studio "set up," in order to go on painting. This dichotomy between the spirit of his training and the spirit of more modern times was noted by Brush, who observed many years after his apprenticeship with Gérôme:

> He was one of the kindest men and I believe the most intelligent master then to be found. It is not his fault that I refuse to call those years spent at the Beaux-Arts *training*. Nothing is sadder to look back upon than the misguidance of serious old men leading enthusiastic youths astray, and this is all that an academy of fine arts has ever done. Never did a man fill his position more faithfully and more earnestly than did Gérôme. Never did a young band of pupils work more enthusiastically to bring about the decline of the fine arts than we did. Never did a government lay finer plans on paper than the French, nor was any academy more liberally conducted both towards the foreigners as well as towards the French pupils. All the world realizes, however, that something is wrong when they go to the annual exhibitions. The something wrong is that the art of painting cannot be kept alive by the methods employed unless the government can supply the youth with a subject. It is of little use to furnish the means for acquiring the art of imitation, for the very kind of imitation which became popular was precisely the kind not wanted. . . . We were taught the art of painting some monks in a wine cellar, a priest in a garden with a red umbrella, a man being shaved, a Moor being executed. The better we learned to do these things the more were we unfitted to do a noble subject on a wall. They are two different arts.[85]

85. Quoted in Bowditch, *Brush*, pp. 10–11.

69. William MacGregor Paxton, *Girl at the Telephone*, 1905. Oil on canvas. Signed and dated. 29 x 19½ inches. Galleries Maurice Sternberg, Chicago.

It was not just the government that failed to "supply the youth with a sub-ject." It was the very character of the modern era that thwarted those steeped in the tradition of academic realism. When, in fact, "a noble subject on the wall" was required, the results were often very ambitious and very odd. For example, when Blashfield attempted a distillation of the realities of turn-of-the-century in-dustry and technology, he produced the labored allegory of *The City of Pitts-burgh Offering Her Iron and Steel to . . . the World* (fig. 39). A product of the collision between nineteenth-century academic principles and modern realities, this celebration of industry is a fascinating manifestation of the turn-of-the-century American mural movement. However, it is far less convincing to twentieth-century eyes than are the straightforward documentary photographs by Lewis Hine of Pittsburgh's blast furnaces. Paxton's *Girl at the Telephone* (1905; fig. 69), though far less ambitious than Blashfield's mural, seems no less awkward as an accommodation of the academic style to a new subject. The twentieth-century's revolutionary stylistic tendencies, and its emphasis upon originality, have also undermined esteem for the academic style of Blashfield or Paxton, who unabashedly depended upon the principles of their training rather than departing from them.

Without either endorsing or decrying late-nineteenth-century French aca-demic tendencies and their residue in the works of American painters, we owe these tendencies consideration if we are to understand that period in our history. If we acknowledge that Americans of the period seemed to have optimistically sought to redefine their "American-ness" in terms of their ability to assimilate the best that the world appeared to offer, we can understand American artists' attraction to the Ecole des Beaux-Arts. To recognize their belief that Gérôme was "the most intelligent master then to be found" is not to prefer his works to those of Manet, but to understand the impact of collectors' taste for his paintings upon American artists who hoped to rival him. To rehabilitate Bridgman is not to suggest that he deserves approbation equal to that accorded him in the 1870s. It is, rather, to comprehend late nineteenth-century American pride in his cos-mopolitanism, fascination with the exotic locales he recorded, and taste for his academic finesse. And to restore Eakins to a cosmopolitan context is not to de-mean his accomplishments. It is, rather, to appreciate even more his intelligent, sensitive, and convincing conjoining of European academic ideals with Ameri-can thematic resources.

APPENDIX

A Roster of Gérôme's American Pupils, 1864–1903

SOURCE: Archives Nationales, Paris, Archives de l'Ecole Nationale Supérieure des Beaux-Arts. *Registre d'inscription des élèves dans les ateliers de peinture, sculpture, architecture et gravure. 1863–1875* (AJ52: 246); *Registre d'inscription des élèves dans les ateliers de peinture, sculpture, architecture, ateliers extérieurs. 1874–1945* (AJ52:248).

NOTE: I have integrated the two registers cited above to clarify the chronology of inscription in Gérôme's atelier at the Ecole des Beaux-Arts from 1863 to 1903. In transcribing entries, I have conformed variant abbreviations to a consistent style, corrected and expanded some artists' names, and added the dates of students' matriculation in the Ecole proper where pertinent. Researchers should be attentive to the possibility of multiple registrations and the consequent repetition of names.

The format of each entry is as follows:

name of pupil; inscription number
place of birth; date of birth
address in Paris; date of inscription in the atelier

This list represents a slightly corrected version of that which I published in *The American Art Journal* 13 (Autumn 1981): 80–84. I am sure that other researchers interested in the extent of Gérôme's influence upon American painters will share my thanks to the *Journal* for permitting its reprinting here.

Wilmarth, Lemuel [Everett] 53
New York (États-Unis), 11 novembre 1840
12 rue Véron [n.d.; no entries dated until
 28 mai 1866]

Eakins, Thomas 116
Philadelphie (États-Unis), 25 juillet 1844
46 r. Vaugirard; 25 octobre 1866

Moore, Harry [Humphrey] 117
Philadelphie (États-Unis), 2 juillet 1844
43 bis r. Galilée; 29 octobre 1866
[matriculated 25 mars 1867; 21 octobre 1867]

Shinn, Earl 118
Philadelphie (États-Unis), 8 novembre 1839
3 r. Dauphin; 3 novembre 1866

Bridgman, [Frederick Arthur] [Reg:
 Frédéric] 129
Tuskegee (États-Unis], 1848
12 r. Jacob; 10 février 1867

Tuckerman, Ernest 139
New York (États-Unis), 16 novembre 1842
15 r. Presbourg; 26 avril 1867

[*Niemeyer*, John Henry] [Reg: Nimeyer,
 Jean] 161
Breme (Allemagne), "citoyen américain,"
 25 juin 1839
28 r. Jacob; 16 octobre 1867

MacCauley, Francis 190
Philadelphie (États-Unis), 29 avril 1844
11 r. Colisée; 9 novembre 1868

[*Eaton*, D. Cady] [Reg: D. Cady,
 Eaton] 225
New York (Amérique), 16 juin 1837
115 r. de Chaillot; 10 janvier 1870

Newcomb, John Jay 235
Boston (Massachusetts), 6 octobre 1849
5 r. Ravignan; 14 mai 1870

Gaylord, Thomas 256
(États-Unis, Amérique), 1850
Hôtel du Périgord; 23 décembre 1871

Ward, Edgar [Melville] 265
New York (États-Unis), 24 février 1845
58 r. Jacob; 12 mars 1872
[matriculated 22 octobre 1872; 18 mars 1873;
 21 octobre 1873; 17 mars 1874]

Love, John Washington 274
Indiana (Amérique), 10 août 1851
63 r. Seine; 2 juillet 1872

Van Schaick, Stephen [Wilson] 279
New York (États-Unis), 22 septembre 1848
31 r. de Seine; 18 octobre 1872

Joseph, Frederick 280
New York (États-Unis), 18 mai 1847
63 r. de Seine; 18 octobre 1872

[*Eaton*, Wyatt] [Reg: Wyatt, Eaton] 282
New York (États-Unis), 6 mai 1849
63 r. de Seine; 19 octobre 1872

Bachelder, Greene William 285
Brookfield (États-Unis), 11 juin 1851
1 r. Racine; 21 octobre 1872

Woodward, Wilbur [Winfield] 288
Indiana (États-Unis), 8 janvier 1851
45 r. de Seine; 26 octobre 1872

Stewart, [Julius L.] [Reg: Julès] 318
Philadelphie (États-Unis), 6 septembre 1855
22 r. Cours-la-Reine; 19 mai 1873

Mason, [Henry] [Reg: Henri] 325
New York (États-Unis), 10 janvier 1855
47 r. Faub. St. Honoré; 3 octobre 1873

Volk, [Stephen Arnold] Douglas 330
Massachusetts (États-Unis), 23 février 1856
63 r. de Seine; 13 octobre 1873

Weir, Julian [Alden] 334
West Point (États-Unis), 30 août 1852
63 r. de Seine; 21 octobre 1873
[matriculated 27 octobre 1874; 24 août 1875;
 20 mars 1877]

Blackman, Walter 335
Chicago (États-Unis), 1 décembre 1847
11 r. Balzac; 21 octobre 1873

Brush, [George deForest] [Reg:
 Georges] 336
Shelbaville (États-Unis), 28 septembre 1854
76 r. de Seine; 29 octobre 1873
[matriculated 22 mars 1876; 19 mars 1878]

Pennington, [Robert Goodhal Harper] [Reg:
 William] 356
Baltimore (États-Unis), 9 octobre 1854
8 av. Friedland; 24 janvier 1874

[*Gortelmeyer*, Frederick] [Reg: Gortelsmeyer,
Frédéric] 359
New York (États-Unis), 8 mai 1848
158 B^d Montparnasse; 11 février 1874

Marchant, [George] [Reg: Georges] 370
Providence (États-Unis), 10 mai 1853
25 r. Rollin; 8 avril 1874

Bowlend, [George Browne] [Reg:
Georges] 377
New York (États-Unis), 16 juin 1845
44 r. Jacob; 11 juillet 1874

Bates, Dewey 378
Philadelphie (États-Unis), 22 novembre 1851
4 r. Racine; 21 septembre 1874

Hamilton, John [McLure] 379
Philadelphie (États-Unis), 31 janvier 1853
5 r. de Douai; 21 septembre 1874

O'Kelly, Aloysius 383
Dublin (Irlande), juin 1851
4 r. St. Sulpice; 7 octobre 1874

Hunt, [Edmond] Aubrey 384
Boston (États-Unis), 7 février 1855
4 r. Budé; 9 octobre 1874

Plumb, Henry [Grant] 385
New York (États-Unis), 15 avril 1848
5 r. Campagne 1^{ère}; 10 octobre 1874
[matriculated 22 mars 1876; 14 août 1876;
 20 mars 1877]

Picknell, William [Lamb] 400
Boston (États-Unis), 23 octobre 1853
13 r. des B^x Arts; 5 décembre 1874

Plumb, Henry [Grant] 447
New York (Amérique), 15 avril 1848
13 Carrefour de l'Odéon; 27 mars 1876
[matriculated 22 mars 1876; 14 août 1876;
 20 mars 1877]

Thayer, [Abbott Handerson] [Reg:
Abbot] 451
Boston (Amérique), 12 août 1849
20 av. Victoria; 12 avril 1876
[matriculated 22 mars 1876]

Johnston, John [Bernard] 456
Boston (États-Unis), 10 décembre 1848
15 r. Jacob; 7 juin 1876

James, [Frederick] [Reg: Frédéric] 472
Philadelphie (Amérique), 20 février 1847
3 r. de la G^{de} Chaumière; 19 octobre 1876

[*Rook*], Edward [Francis] [Reg:
Rooke] 475
New York (Amérique), 5 mai 1854
20 av. Victoria; 20 octobre 1876

Boggs, Frank Myers 481
New York (Amérique), 6 décembre 1854
20 av. Victoria; 30 octobre 1876

Robinson, [Theodore] [Reg: Théodore] 482
Irasberg (Amérique), 3 juin 1852
81 b^d Montparnasse; 2 novembre 1876
[matriculated 22 mars 1876; 20 mars 1877;
 15 août 1877; 19 mars 1878]

Sargent, Richard 494
Boston (Amérique), 21 mars 1854
50 r. Jacob; 25 janvier 1877

Johnson, James 524
Burlington (Amérique), 9 janvier 1857
63 r. de Seine; 5 juin 1877

Curtis, [Ralph Wormeley] [Reg: Raoul] 526
Boston (États-Unis), 28 août 1855
1 r. du Dauphin; 9 juin 1877

Evans, Joseph T. 543
New York (États-Unis), 29 octobre 1857
1 place d'Eylau; 8 octobre 1877

Butler, Edward [Riché] 546
Sacramento (Californie), 21 décembre 1856
35 r. de Tournon; 13 octobre 1877
[matriculated 13 août 1878]

Dyer, Lowell 547
Brooklyn (Amérique), 3 décembre 1856
18 B^d Montrouge; 13 octobre 1877

Brown, Walter F[rancis] 549
Providence (Rhode Island, États-Unis),
 10 janvier 1853
36 r. Bonaparte; 15 octobre 1877

Whitehouse, [Henry] R. [Reg: Henri] 552
New York (États-Unis), 5 août 1856
2 r. []; 31 octobre 1877

Williamson, John C[harters] 555
Brooklyn (États-Unis), 5 août 1856
2 r. []; 31 octobre 1877

Cresson, Hilborn Thompson 571
Philadelphie (Amérique), 12 septembre 1852
58 r. Madame; 9 janvier 1878
[matriculated 18 mars 1879]

Decomps, Eugen[e] 593
Brooklyn (Amérique), 19 août 1858
86 r. N.D. des Champs; 1 octobre 1878

Plimpton, William [P.] 598
Brooklyn (États-Unis), 8 janvier 1857
7 r. Scribe; 7 octobre 1878

Woodcock, Percy F[ranklin] 602
New York (États-Unis), 17 août 1854
Hôtel d'Alger (rue d'Alger); 14 octobre 1878

Cranford, Kenneth R. 609
Brooklyn (États-Unis), 14 mars 1857
50 r. Jacob; 30 octobre 1878

Cox, Kenyon 626
Warren (Ohio, Amérique), 27 octobre 1856
62 r. de Seine; 8 février 1879
[matriculated 13 août 1878]

Grayson, Clifford Prevost 629
Philadelphie (Amérique), 14 juillet 1858
3 r. Clôture; 14 février 1879
[matriculated 12 août 1879]

Harrison, Thomas Alexander 637
Philadelphie (États-Unis), 17 janvier 1852
33 r. de Tournon; 2 mai 1879

Errett, Henry F[]mby 643
Muir (État de Michigan, États-Unis), 17 sep-
 tembre 1859
30 r. Mazarine; 1 octobre 1879

Makin, Richard Laurence 644
New York (États-Unis), 12 décembre 1857
49 r. Galilée; 1 octobre 1879

Celarié, Gaston Frédéric Théodore 667
Les anges (Californie), "français," 17 mai 1854
7 r. de Seine; 13 novembre 1879

Hardie, Robert [Gordon] 677
Brattleboro (États-Unis), 29 mars 1854
22 Bd d'Enfer; 16 janvier 1880

Allen, William [Sullivan] [Reg:
 Sullivant] 698

New York (États-Unis), 8 octobre 1861
Hôtel de Prince Albert, r. S. Hyacinthe;
 15 juin 1880

Levy, Herbert 699
New York (États-Unis), 22 juin 1857
73 Bd St. Germain; 28 juin 1880

Chambers, [George] W. [Reg: Georges] 705
St. Louis (Amérique), 29 juin 1857
1bis r. Descombes; 1 octobre 1880

Shields, Thomas W. 707
New York (Amérique), 29 mars 1849
137 Bd Malesherbes; 4 octobre 1880
[matriculated 13 août 1878]

Stokes, Frank Wilburt 752
Philadelphie (Amérique), 27 novembre 1859
73 Bd St. Germain; 5 avril 1881

King, James [S.] 757
New York (Amérique), 18 décembre 1853
64 r. de Clichy; 3 mai 1881

Hoeber, Arthur Burnet 774
New York (Amérique), 23 juillet 1854
33 r. de Tournon; 18 octobre 1881

Lasar, Charles Auguste 780
Johnstown (Pennsylvanie), 8 février 1856
6 r. Boissonade; 18 novembre 1881
[matriculated 24 mars 1882; 4 août 1882;
 13 mars 1883; 11 mars 1884]

Sawyer, Wallace 789
New York (États-Unis), 26 mars 1859
73 Bd St. Germain; 16 décembre 1881

Harrison, Thomas Alexander 795
Philadelphie (Amérique), 17 janvier 1853
33 r. de Tournon; 13 mars 1882

Peel, Paul 799
Philadelphie (Amérique), 7 novembre 1860
54 r. d'Assas; 17 avril 1882

Strickler, John Ramsey 834
Peoria (Illinois), 6 février 1862
13 r. des Bx Arts; 15 novembre 1882

Bunker, [Dennis] Miller [Reg: Denis] 844
New York (Amérique), 6 novembre 1858
10bis r. de la Gaîté; 8 janvier 1883
[matriculated 18 mars 1884]

Moran, Thomas William 882
Toronto (Canada), 27 avril 1856
44 rue Jacob; 10 octobre 1883
[matriculated 5 août 1884]

[*Bridgman*, George] B. [Reg: Bridgmann,
 Georges] 883
Toronto (Canada); 5 novembre 1865
44 rue Jacob; 10 octobre 1883
[matriculated 11 mars 1884; 5 août 1884;
 21 juillet 1887]

Saunders, [Theodore] [Reg: Théodore] 885
Kingston (Canada), 18 février 1862
63 r. de Seine; 6 novembre 1883

P[]iper, Edwin H. 888
Boston (États-Unis), 22 avril 1861
Chez M. Hottinguer, 38 r. de Provençe;
 7 novembre 1883

Dodge, [William deLeftwich] [Reg: Willie
 L.] 893
Richmond (Virginia, États-Unis), 9 mars
 1867
53 rue Bonaparte; 10 novembre 1883
[matriculated 4 avril 1885]

Fischer, James Randolph 896
Philadelphie (Amérique), 23 décembre 1862
29 Bd Rochechouart; 16 novembre 1883

[note renumbering from 14 mars 1884]

Dodge, William [deLeftwich] 8
Richmont (États-Unis), 9 mars 1867
53 r. Bonaparte; 19 octobre 1885
[matriculated 4 avril 1885]

Comès, Henri Gustave Auguste 47
Nlle Orleans (États-Unis), 14 juillet 1868
11 rue Nicolo; 21 mars 1886
[matriculated 15 mars 1887]

Longman, John B. 52
Toronto (Canada), 11 octobre 1860
203 Bd d'Enfer; 18 mai 1886
[matriculated 15 mars 1887; 29 février 1888]

Peters, [DeWitt] Clinton [Reg: DeWit] 53
Baltimore (États-Unis), 11 juin 1865
41 rue du Luxembourg; 18 mai 1886
[matriculated 21 juillet 1887]

[*Levy*], Henry L. [Reg: Lévy] 56
Hartford (Amérique), octobre 1868
2 rue Duperré; 1 mars 1888
[matriculated 28 février 1888]

Wood, James L[ongacre] 58
Philadelphie (Amérique), 3 avril 1867
30 Bd Excelmans; 1 mars 1888
[matriculated 29 février 1888; 23 février
 1891]

Browne, [Charles Francis] [Reg: Chaz.
 Z.] 61
Natick (Amérique), mai 1868
20 Bd Raspail; 22 mars 1888
[matriculated 29 février 1888; 6 mars 1889]

Vedder, S[imon] H[armon] 63
New York (Amérique), 9 octobre 1866
103 rue Vaugirard; 12 octobre 1888
[matriculated 18 juillet 1888; 16 juillet 1889]

Linson, Corwin K[napp] 68
Brooklyn (États-Unis), 25 février 1864
203 Bd Raspail; 12 avril 1889
[matriculated 6 mars 1889]

Rosenthal, Albert 79
Philadelphie (États-Unis), 30 janvier 1863
9 rue de la Michodière; 18 octobre 1890

Reevs, George [M.] 80
Yonkers (États-Unis), 26 août 1864
203 Bd Raspail; 18 octobre 1890

Gill, Charles Ignace 81
Sorel (Canada), 21 octobre 1871
21 rue de Tournon; 18 octobre 1890

Dubé, Louis Théodore 84
St. Roch (Canada), 7 avril 1862
59 av. de Saxe; 20 octobre 1890

Perry, Roland [Hinton] 85
1869
5 rue Boissonade; 23 octobre 1890
[matriculated 4 mars 1890]

Humphreys, Albert 88
Cincinnati (États-Unis), 9 août 1863
203 Bd Raspail; 25 octobre 1890

Paxton, William [MacGregor] 90
Baltimore (États-Unis), 22 juin 1869
5 Cité Fénelon; 27 octobre 1890

Knight, Arthur 92
New York (États-Unis), 1 mai 1867
203 B^d Raspail; 28 octobre 1890

Beck, [Martin Augustin] 94
Harrisburg (États-Unis)
203 B^d Raspail; 31 octobre 1890
[matriculated 23 février 1891]

Davis, Garry 95
Cincinnati (États-Unis), 15 avril 1865
191 r. de l'Université; 4 novembre 1890

Clarke, Thomas Shields 100
Pittsburg (États-Unis), 25 avril 1862
20 rue Clément-Marot; 17 novembre 1890

Gravel Lajoie, Louis Charles 102
Montréal (Canada), 30 mai 1868
43 rue Cherche-Midi; 29 novembre 1890

Hill, R[oswell] S[tone] 105
Bridgeport (États-Unis), 17 avril 1861
9 r. Campagne 1^{ère}; 3 décembre 1890

Walters, Robert Randolph 107
Hoboken (États-Unis), 13 octobre 1865
86 r. N.D. des Champs; 8 décembre 1890

Bartlett, Clarence [Drew] 108
Athens (États-Unis), 14 août 1863
9 rue Campagne première; 10 décembre 1890

Bial [Beal?], H. Martin 110
Boston (États-Unis), 15 juillet 1861
9 rue LeVerrier; 16 décembre 1890

✱ *Clawson*, J[ohn] W[illard] 117
Salt Lake (États-Unis), 18 janvier 1861
36 r. de Penthièvre; 10 janvier 1891

Leavitt 118
Boston (États-Unis), 8 avril 1868
6 r. Richepanse; 10 janvier 1891

Talcott, Allen B[utler] 119
Hartford (États-Unis), 8 avril 1868
9 r. Campagne 1^{ère}; 2 mars 1891

Horning, B[enjamin] F. 123
Easton (États-Unis), 11 novembre 1862
12 rue de Seine; 23 mars 1891

Hagaman, James [H.] 124
Rochester (États-Unis), 26 juin 1866
19 rue de Seine; 23 mars 1891
[matriculated 23 février 1891]

Loeb, Louis 125
Cleveland (États-Unis), 7 novembre 1866
203 B^d Raspail; 25 mars 1891
[matriculated 23 février 1891]

Mielziner, [George] [Reg: Georges] 126
New York (États-Unis), 8 décembre 1869
203 B^d Raspail; 8 avril 1891

Harris, William Laurel 128
Brooklyn (États-Unis), 18 février 1870
[no address given]; 15 octobre 1891

Landis, Benj[amin] F. 134
Lancaster (États-Unis), 21 août 1865
2 rue Racine; 17 novembre 1891

[*MacCameron*], Robert [Reg: Cameron, Robert Mac] 135
Chicago (États-Unis), 14 janvier 1866
[no address given]; 19 novembre 1891

Roudanez, Ilaric 136
N^{elle} Orleans (États-Unis), 4 janvier 1873
20 rue Pestalozzi; 24 novembre 1891

Potter, John Briggs 144
Ro[] (États-Unis), 13 décembre 1864
24 r. Bonaparte; 15 mars 1892

Coburn, [Frederick] Simpson [Reg: Frédéric] 147
Melbourne (Canada), 18 mars 1871
1 rue Leclerc; 25 avril 1892

Hodges, George Schuyler 150
Pontiac (États-Unis), 3 mars 1864
74 B^d Montparnasse; 10 juin 1892

Paradis, Jobson 151
St. Jean (Canada), 22 février 1871
[no address given]; 10 juin 1892

Lemarche, Ulric 163
St. Henri (Canada), 15 décembre 1868
66 rue N.D. des Champs; 2 novembre 1892

Stewart, William W[right] 166
Philadelphie (États-Unis), 13 février 1865
5 rue Boissonade; 14 novembre 1892

Finn, James Wall 169
New York (États-Unis), 12 août 1866
25 rue Jacob; 14 novembre 1892

Dodge, Robert [L.] 182
[inscribed] 26 octobre 1893
[matriculated 31 juillet 1894]

Hinton, Charles Louis 183
Itahca (États-Unis), 18 octobre 1869
203 B d Raspail; 26 octobre 1893

Guthrie, Harry Melville 184
New York (États-Unis), 25 octobre 1872
203 B d Raspail; 26 octobre 1893

Waltensperger, Charles E. 191
Detroit (États-Unis), 10 avril 1870
[no address given]; 8 novembre 1893

Wood, Bringer Trist 200
N elle Orleans (États-Unis), 10 juin 1868
12 r. Boccador; 11 décembre 1893

Barlow, Myron 204
Ionia (États-Unis), 15 avril 1871
22 rue Delambre; 20 janvier 1894
[matriculated 8 mars 1897]

Andrew, Richard 218
Belfast (États-Unis), 9 janvier 1869
6 rue Boissonade; 15 octobre 1894

Brown, Harold H[aven] 219
Malden (États-Unis), 6 juin 1869
6 rue Boissonade; 15 octobre 1894

Altmann, Aaron 220
San Francisco (Californie), 28 octobre 1872
13 rue Leverrier; 15 octobre 1894

Cueull, Edward Alfred 221
San Francisco (Californie), 6 août 1875
131 B d Montparnasse; 15 octobre 1894

Funk, George C. 222
Detroit (Amérique), 13 décembre 1869
131 B d Montparnasse; 15 octobre 1894

Wolfrom, Philip H. 226
Kansas City (États-Unis), 1 mars 1870
152 B d Montparnasse; 16 octobre 1894

Morris, Edmond Montague 228
Perth (Canada), 18 décembre 1871
95 r. Vaugirard; 19 octobre 1894

Dodge, [Ozias] [Reg: C. Benjamin]
Morrisville (États-Unis), 14 février 1868
23 rue Oudinot; 2 novembre 1894

Tudor-Hart, Ernest Percival 233
Montréal (Canada), 27 décembre 1873
6 avenue Frochot; 7 novembre 1894

Perard, Victor Simon 244
Neuilly (Seine), 16 janvier 1867
2 rue Fléchier; 22 avril 1895

Mack, Edward 248
Cincinnati (États-Unis), 25 janvier 1870
66 r. N.D. des Champs; 19 juin 1895

Piazzoni, Gottardo 251
Intragna (Suisse), 14 avril 1872
11 Impasse du Maine; 23 juillet 1895

Lewis, Arthur Adelbert 271
Mobile (États-Unis), 7 avril 1873
13 bis rue Campagne 1ère; 17 juin 1896

Adolph[e], Albert J[ean] 275
Philadelphie (États-Unis), 17 février 1870
52 avenue du Maine; 19 octobre 1896
[matriculated 13 juillet 1897]

Bright, John Irwin 284
Pottsville (États-Unis), 13 août 1869
18 Impasse du Maine; 29 mars 1897
[matriculated 8 mars 1897; 13 juillet 1897]

Parker, Lawton S. 286
Kearney (États-Unis), 7 août 1868
79 B d Montparnasse; 29 mai 1897
[matriculated 6 mars 1889, 16 juillet 1889;
 18 novembre 1897; 21 mai 1898]

Nuese, Carl J. 288
Titusville (États-Unis), 8 novembre 1876
54 r. N.D. des Champs; 23 juin 1897

Marcou, Samuel A. 292
New York (États-Unis), 13 mars 1874
38 rue des Sts. Pères; 18 octobre 1897

Porter, George Taylor 307
Lawrence (États-Unis), 26 octobre 1876
58 rue d'Assas; 17 février 1898

Chalfin, Paul 315
New York (États-Unis), 2 novembre 1874
61 rue de Varenne; 15 octobre 1898
[matriculated 9 novembre 1898]

Vaillant, Louis David 316
Cleveland (États-Unis), 14 décembre 1875
7 rue Mezières; 15 octobre 1898

[*MacLaughlan*, Donald] Shaw [Reg: Laugh-
 lin, Shaw Mc] 317
Charlottetown (Canada), 9 novembre 1876
18 bis Impasse du Maine; 17 octobre 1898

Marcus, Isidor
Werwisan (Russie), 5 octobre 1875
117 rue St. Antoine; 10 novembre 1898

Bechtel, Benjamin Robert 321
Westchester (États-Unis), 23 décembre 1871
9 rue des Fourneaux; 18 novembre 1898

White, Charles Henry 331
Hamilton (Canada), 14 avril 1878
156 b d Montparnasse; 2 mai 1899

Fabien, Henri 363
Montréal (Canada), 8 juillet 1878
60 r. de Vaugirard; 5 février 1901

Nocquet, Paul [Ange] 398
Ixelles (Belgique), 2 avril 1877
65 b d Arago; 13 novembre 1902

Charron, Adéland Emile 422
Ottawa (Canada), 14 juin 1878
20 rue de l'Estrapade; 31 octobre 1903

Index